祝福
良善
Devotion
Joy
Forbearance
Goodness
忍辱
奉獻
喜樂
Peace
真誠
Sincerity
慈悲
寬容

GUIDE BOOK
OF
MUSEUM
OF
WORLD RELIGIONS

宗教文物之美

道德
懺悔
Confession
Love
Compassion
修行
Cultivation

世界宗教博物館
MUSEUM OF WORLD RELIGIONS

尊 重 每 一 個 信 仰
Respect For All Faiths

包 容 每 一 個 族 群
Tolerance For All Cultures

博 愛 每 一 個 生 命
Love For All Life

埃及
Egypt

馬雅
Maya

印度教
Hinduism

基督宗教
Christianity

神道教
Shinto

伊斯蘭教
Islam

猶太教
Judaism

佛教
Buddhism

道教
Daoism

錫克教
Sikhism

目錄 Contents

6 | 創辦人的話 Founder's Words

8 | **啟程** Departure
12 | 水幕牆 Water Curtain
14 | 朝聖步道 Pilgrims' Way
16 | 掌痕手印 Palm print

18 | **宇宙觀** Understanding of the Cosmo
20 | 金色大廳 Golden Lobby
24 | 宇宙創世廳 Creations

26 | **生命觀** Understanding of Life
28 | 生命之旅廳 Hall of Life's Journey
30 | 初生 Birth
32 | 成長 Coming of Age
34 | 中年 Mid -Life
36 | 老年 Old Age
38 | 死亡及死後世界 Death and Afterlife

40 | 生命覺醒區 Awakenings
42 | 靈修學習區 Meditation Gallery
44 | 華嚴世界 Avatamsaka World

46 | **匯聚** Converge
48 | 世界宗教展示大廳 Great Hall of World Religions
50 | 古埃及 Ancient Egypt
54 | 馬雅 Maya
58 | 猶太教 Judaism

62 | 基督宗教 Christianity

66 | 伊斯蘭教 Islam

70 | 印度教 Hinduism

74 | 佛教 Buddhism

78 | 錫克教 Sikhism

82 | 道教 Daoism

86 | 神道教 Shinto

90 | 民間信仰 Religious Life of the Taiwanese

94 | 世界宗教建築模型展示區 The Greatest Sacred Buildings

96 | 圓頂清真寺 Dome of the Rock

98 | 路思義教堂 Luce Chapel

100 | 金廟 Golden Temple

102 | 伊勢神宮 Ise Grand Shrine

104 | 濕婆神廟 Kandariya Mahadev Temple

106 | 夏特大教堂 Chartres Cathedral

108 | 佛光寺大殿 Buddha's Light Temple

110 | 婆羅浮屠 Borobudur

112 | 聖母升天堂 Assumption Cathedral (Trinity St. Sergius Monestary)

114 | 舊新會堂 Altneuschl (Old-New Synagogue)

116 | 感恩紀念牆 Wall of Gratitude

120 | 祝福區 Blessings

122 | 觀展之道 Visitor's Route

124 | **延伸** Extension

126 | 生死晝夜：於死亡中前行
Bright as night , dark as day : A Walk with the Death

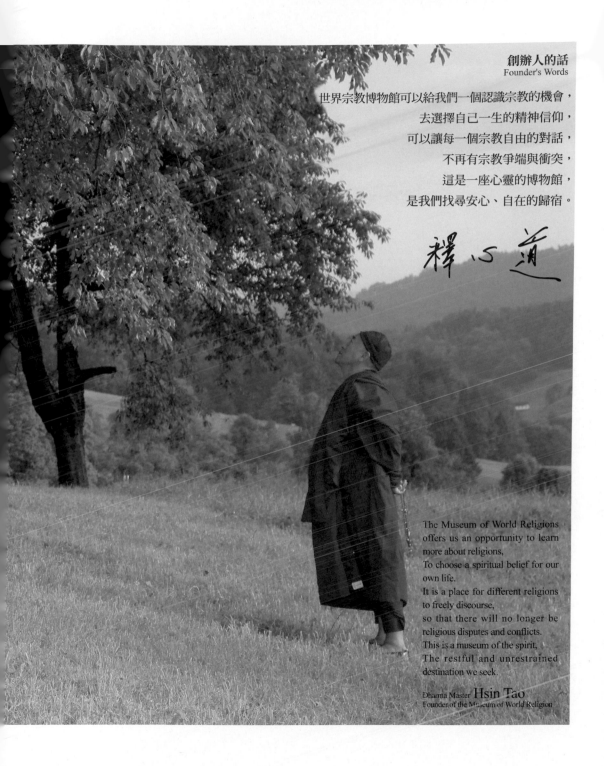

世界宗教博物館可以給我們一個認識宗教的機會，

去選擇自己一生的精神信仰，

可以讓每一個宗教自由的對話，

不再有宗教爭端與衝突，

這是一座心靈的博物館，

是我們找尋安心、自在的歸宿。

釋心道

The Museum of World Religions
offers us an opportunity to learn
more about religions,
To choose a spiritual belief for our
own life.
It is a place for different religions
to freely discourse,
so that there will no longer be
religious disputes and conflicts.
This is a museum of the spirit,
The restful and unrestrained
destination we seek.

Dharma Master **Hsin Tao**
Founder of the Museum of World Religion

啟程

Departure

星光相互照映，交織成無限美好的宇宙光景

The stars shine on each other, forming an infinite and wonderful universe.

十道彩條，以不同的宗教啟示探究世界十大宗教的文化。十道色彩，給人祈禱安頓身心的啟示和力量，推動尊重、包容與博愛的理念。

這十道光彩僅是開端。求解的過程是一條道路，終點在哪？我們會走向那個答案嗎？

光，流轉，滌塵。

電梯上行的同時，穩定呼吸，隨著梯內燈光的流動，淨空思緒。

電梯開門，就著光前進吧。

「百千法門、同歸方寸。」
電梯開門看到的這八個大字，取自禪宗四祖道信禪師的偈語，說的是各種不同的宗教或法門，都終歸要回到自己的內心。這也是世界宗教博物館的宗旨，不僅僅是介紹世界十大宗教，也是帶領參觀者走入自己的內心。

在剛剛走進博物館的時刻，我們不先結論，從心開始，啟動探索的旅程。
待回程，看內心是不是會有這樣的感動？
這八字箴言，存在心間。

The 10 colorful stripes represent the world's 10 religions. Visitors are about to explore through different religious revelations. Religions bring enlightenments to us, we can find physical and spiritual peace by worshiping and promoting the ideas of respect, inclusivity and charity.
Starting with these ten beams of light, it is a journey for searching. Where is the destination? Will we know the answer eventually?

Light flows and purifies the air.

Stabilize your breath as the elevator goes up. Clear your mind as the light in the car flows.

When the elevator door opens, step out into the light and go forward.

"The doors to Goodness, Wisdom and Compassion are opened by keys of the heart."
The maxim greets you as soon as the elevator door opens. It is a quotation from the saying of the fourth patriarch of Chan Buddhism, Master Dayi Daoxin. Its meaning is that although there are different religions or approaches, people eventually have to return to their hearts, which is what the Museum of World Religions' goal. The museum's goal is not only to introduce the world's most followed religions, but also to lead visitors into their hearts.

Entering the museum, please don't jump to the conclusion. Just go on an exploration journey from your heart. When heading back, try to find out if you have such a touching understanding and keep the maxim in your mind.

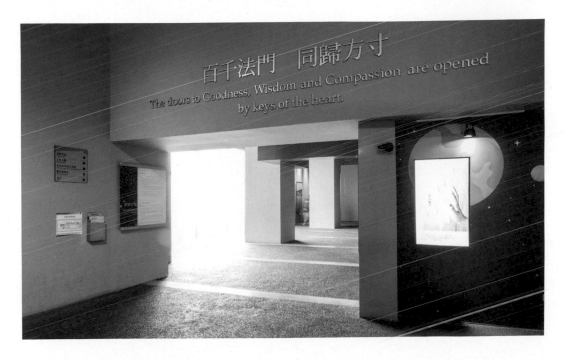

水幕牆
Water Curtain

將手伸向水幕，手勢是迎向水流攫取或順應水流接納？

水是基本的自然元素，帶來生命的水流動不止，總可以洗淨日常的匆忙雜亂，回歸純潔內心。水在各個文化中都常用來當作潔淨和轉化的媒介。

把手伸向水幕牆，讓水滑過指尖，流過手掌，水流的觸感與潺潺水聲，好比生命之初在母體內所感知到的狀態一般，也令人想到不同的宗教傳統中的洗滌和淨化。耶穌基督的約旦河受洗、錫克教上師在沐浴時的啟發、觀世音菩薩灑水度化人間、神道教神社裡的手水舍、伊斯蘭教禮拜前的潔淨儀式，都是由水，帶來潔淨和超越。

Stretch out your hand into the water curtain. Are you using your hand to grab the water or allow it to flow over your hand?

Water is a fundamental natural element. The water that brings life flows forever, and can always wash away the hustle and messiness of daily life and bring you back to your pure heart. Water is used as a medium for purification and transformation in various cultures.

Place your hand into the water curtain and let the water flow through your fingertips and palms. Feeling the touch and hearing the sound of the flowing water may be likened to experiencing the beginning of life in the mother's body. It also reminds people of cleansing and purification in different religious traditions. The baptizing of Jesus in the Jordan River, the revelation received by a Sikh Guru when taking a bath, the Bodhisattva Avalokitesvara's sprinkle of water for the salvation of humanity, the water ablution pavilions in Shinto shrines, and the ablution before Islamic prayers involve water to bring cleanliness and transcendence.

朝聖步道
Pilgrims' Way

不論走得多快，問題一直都在，人類從未停止探究人生的奧妙，「在出生之前，我是誰？」、「我們為何被生而為人？」、「我們為什麼懼怕死亡？」、「知覺是什麼？」

人生的路程是崎嶇模糊，時而平緩、得心應手，時而交雜著痛苦和考驗，就像此刻腳下朝聖步道的磨石子和洗石子路；牆上的朝聖者，有的徐徐前行，有的總要停下來瞻前顧後，走下慎重的一步一腳印。

朝聖者，伴隨著牆上的大哉問和宗教解答，在求知求解的喜悅中前行，他們的生命有方向，伴隨時間的軌跡，往前行，也回歸內心。

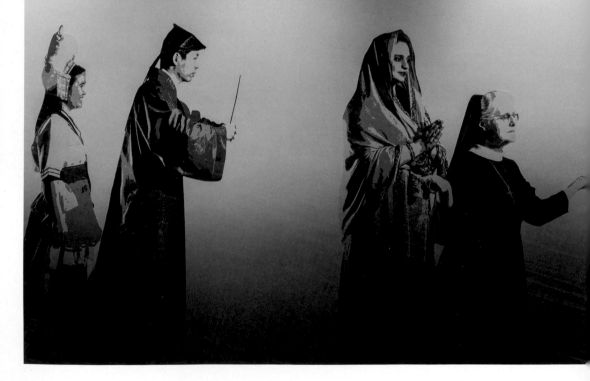

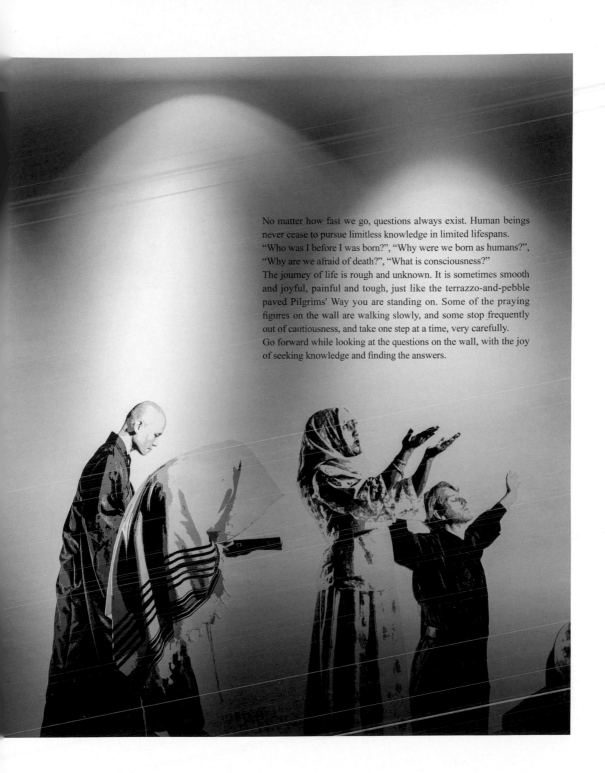

No matter how fast we go, questions always exist. Human beings never cease to pursue limitless knowledge in limited lifespans.

"Who was I before I was born?", "Why were we born as humans?", "Why are we afraid of death?", "What is consciousness?"

The journey of life is rough and unknown. It is sometimes smooth and joyful, painful and tough, just like the terrazzo-and-pebble paved Pilgrims' Way you are standing on. Some of the praying figures on the wall are walking slowly, and some stop frequently out of cautiousness, and take one step at a time, very carefully.

Go forward while looking at the questions on the wall, with the joy of seeking knowledge and finding the answers.

掌痕手印
Palm Print

看著手掌，在牆上印下溫度的掌印

溫存消逝之前，掌溫與環境交相平衡，原來，時間往那裡走……

手，不僅僅作為溝通，更代表著「實踐」。

在求解心靈提升的過程，我做，我會做，我能做，我不斷地做。

而做了什麼，做過什麼，留下什麼，累積了什麼？

作為實踐的手，可以做出承諾。宗教傳統上，手常扮演重要的符號象徵，祝禱、祈願、施予和賜福。

這面牆，留下了每一位來到這裡的觀眾獨一無二的掌印，然後消逝歸零，來來去去，不斷上演；熙來攘往的生命之河，週而復始的時間之流。

Looking at your warm palm prints left on the wall.
Before the prints disappear, the warmth of your palm and the environment are balanced, and that is the time tested way of being…
Hands are not only used to communicate but also represent practice.
In looking for the answer to spiritual growth, think about "what I do," "what I will do," "what I can do," and "what I should keep doing" and reflect on "what I have done," "what did I do," "what did I deliver," and "what did I acquire."
Representing practice, hands can be used to make commitments. When it comes to religious traditions, hands usually play an important role in making symbolic signs, sending wishes, praying, giving, and blessing. Every visitor coming here leaves their unique palm prints on the wall, which will fade away and disappear. The same process continues as visitors come and go, like the running river of life and the looping stream of time.

宇宙觀

Understanding
of
the Cosmo

看見淵遠流長的歷史裡，我們的信仰是什麼模樣？

Pondering what our faith looks like through the long history of mankind.

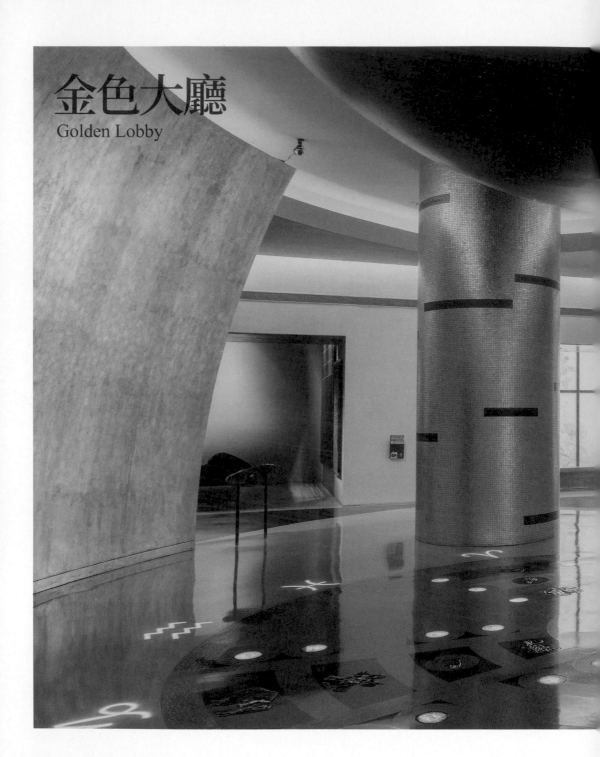

金色大廳
Golden Lobby

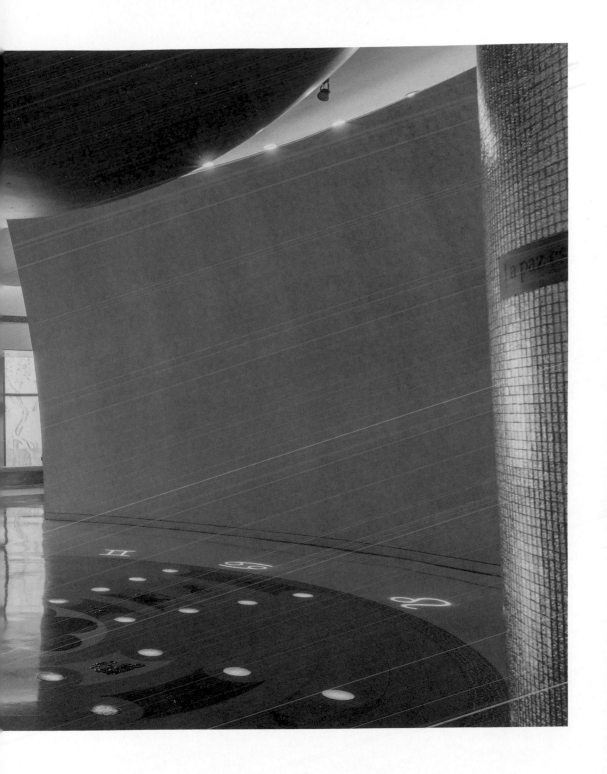

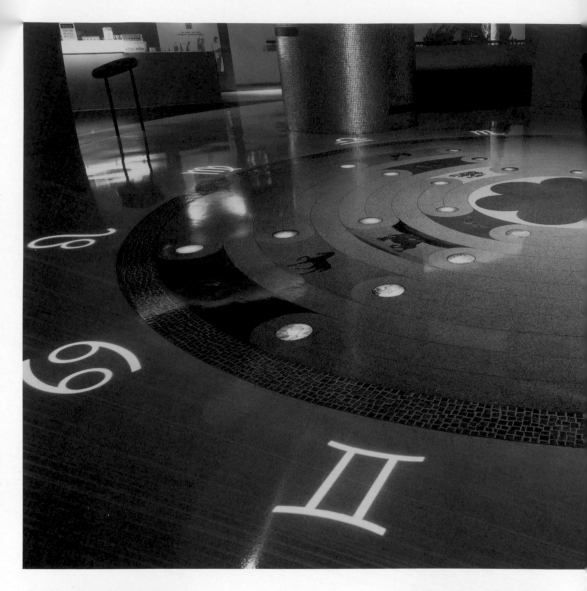

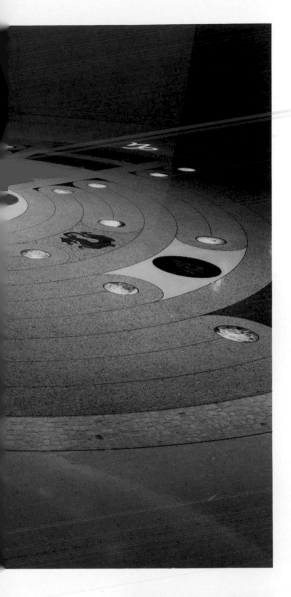

順著朝聖步道和掌印牆，一縷金光，映入眼簾。
它像什麼？如同眼睛的形狀，看到不同語言
的同一句話，愛與和平，是答案。
凝視我的眼，你看到什麼？
凝視你的眼，我看到世界。
撐起穹蒼的，運轉宇宙的，愛與和平是解。
因為「愛是我們共同的真理」，「和平是我
們永恆的渴望」。
在這金色蒼穹下，如同一幅「寰宇圖」，天
花板是天，地板上是凡塵，窗洞暗示著進入
第三界元，是冥間地府的關卡，也象徵對真
理的追尋。那多彩和多樣的顏色與符號，都
有各自宗教中的意義，包含了時間和空間。
我們在這個空間裡，自我變得微小，如同在
廣袤的宇宙空間中，看天地之大，品類之
盛，心思萬千變化，皆有其始。宇宙創世廳
的理論由此展開。

Standing in the center of the resplendent golden lobby,
there are "love is our shared truth" and "peace is our
eternal hope" written in fourteen different languages.
With the golden firmament-like ceiling, the whole space
is like a map of the universe. The ceiling is the heaven;
the floor is the earth; and the window implicitly represents
the portal of the third dimension, which is the entrance of
the lower world, and also symbolizes the pursuit of truth.
A variety of colors and symbols have their own meanings
related to time and space in their respective religions. We
feel small in this space as if we are in the vast cosmic
space. The theories delivered in "Creations" originated
from this idea.

宇宙創世廳
Creations

宇宙是什麼？這世界是怎樣的存在？

生命有源起嗎？從哪裡發生？

不同地方的人，如何理解生命起源？

天大地大，人有多大？

沒有了人的天地，會是什麼光景？

相對於天地之深遠廣大，相對於時間之河的無窮無盡，

人的存在，微妙地，竟相當重大。

因為，我正在這裡，在此地，看著這一切發生，共這一切一同發生！在一個有101個座位的劇場空間裡，我們一同觀看宇宙、世界和人類起源的影片。探究起源的種種可能。

我們透過宇宙的尺度與速度，超越人的格局的方式看著創世神話，博物館的旅程要走進人的生命歷程了，世界已然形成，聽見心跳，脈動生命，誕生……

worlds desc

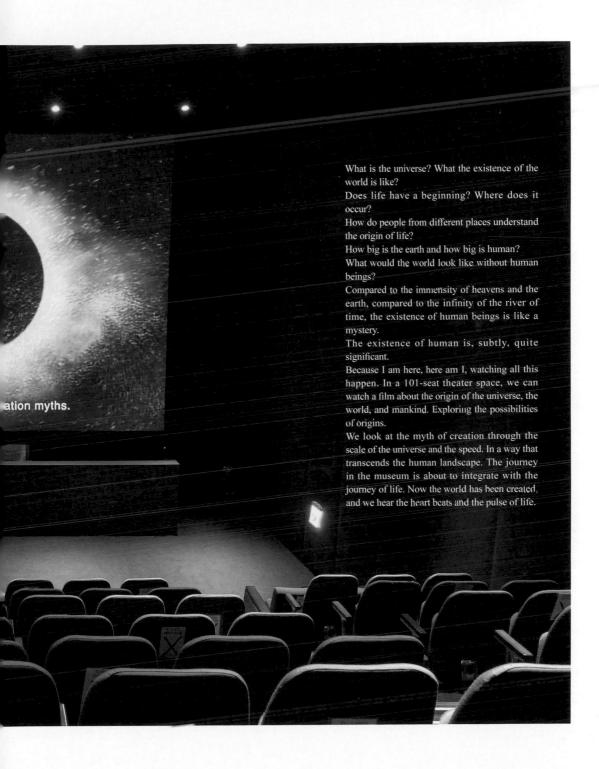

ation myths.

What is the universe? What the existence of the world is like?

Does life have a beginning? Where does it occur?

How do people from different places understand the origin of life?

How big is the earth and how big is human?

What would the world look like without human beings?

Compared to the immensity of heavens and the earth, compared to the infinity of the river of time, the existence of human beings is like a mystery.

The existence of human is, subtly, quite significant.

Because I am here, here am I, watching all this happen. In a 101-seat theater space, we can watch a film about the origin of the universe, the world, and mankind. Exploring the possibilities of origins.

We look at the myth of creation through the scale of the universe and the speed. In a way that transcends the human landscape. The journey in the museum is about to integrate with the journey of life. Now the world has been created, and we hear the heart beats and the pulse of life.

生命觀

Understanding
of Life

用不同的角度重新探索每個人生階段獨特的生命之流

Exploring the unique currents of life at each stage from different perspectives.

生命之旅廳
Hall of Life's Journey

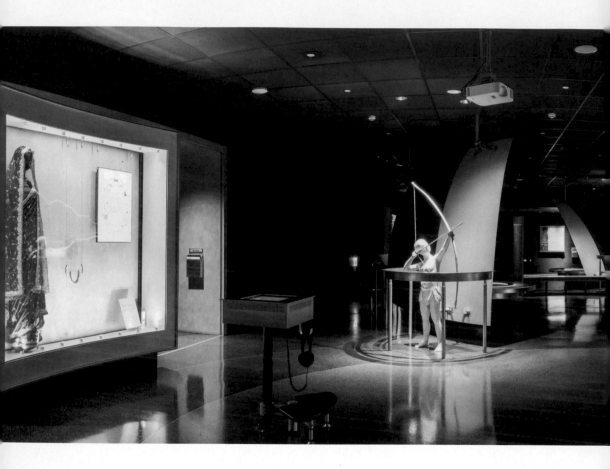

生命的有限，讓人生更為寶貴。人生的種種經驗會在人的有限生命裡不斷累積、豐富和提煉。透過認識不同的群體在人生各重要節點的習俗和展現，我們能夠看到個體與群體，看到生命和死亡所交織成的大千世界。生命有終點。新生的每一個生命依然走上了尋求意義，走向人生終點的旅程。起點從喜悅迎接的「初生」開始，經過延續社群希望的「成長」，承擔與創造生命意義的「中年」，豁達的「老年」，來到未知的「死亡及死後世界」。人們在這條路上不斷地累積。這些累積，成就出在博物館裡技藝超絕的宗教儀典文物，他們代表了人類文明在這個探究過程中的寄託和倚望、崇拜和慶賀。

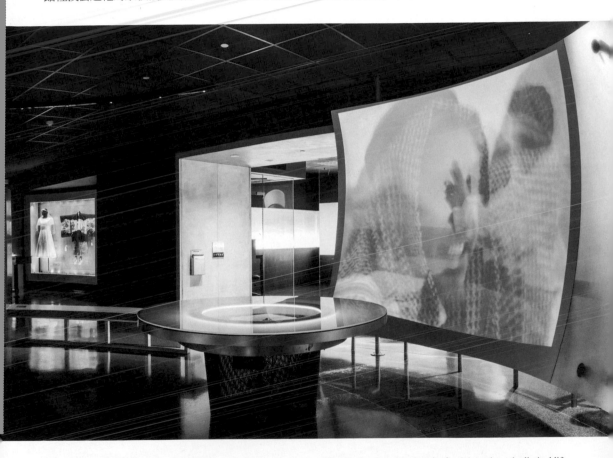

The finite nature of human life makes life valuable. Life's experiences are accumulated, enriched, and refined throughout the limited life of a person. By knowing the customs and expressions of different groups of people at various important events in their lives, we can see the colorful world of individuals and groups, see the world of life and death.

Life has its ending. Each new life embarks on the journey search for meaning from the day one and towards the end of life. It begins with the joyful welcoming of "Birth", continues through "growing up" with hope of the community, the "Mid-Life" of commitment and meaning, the wisdom of "Old Age and arrives at the unknown "Death and Afterlife". People continue to accumulate on this path. These accumulations have led to the highly skilled religious artifacts in our museum, which represent the trust and reliance, worship and celebration of human civilization in this process of inquiry.

初生 Birth

新生命降臨，都是禮物。存活下來的幼小生命，需要祝福，需要運氣，需要襁褓。初生乘載著希望，也是給人類祝福的奇蹟。就像代表希望和可能性的樹一樣，這裡的每一條長凳，都有不同種類的木材製作，象徵著不同的人生階段的意涵。

設置在初生展區的樺木長凳，象徵富饒多產，往往是曠野中最先生長的樹木，蘊含有「幼木成林」的含義，在歐亞大陸的許多文化中，這種樺樹的木材也常常被用來製作搖籃。坐在這條樺木長凳上，靜靜欣賞它的木紋走向，彷彿也觸到它旺盛的生命歷程。

The arrival of a new life is a gift. A life that survived the test of being a fragile newborn needs blessing, luck, and care. A newborn carries hope and is a miracle of blessing to mankind. Like a tree representing hope and possibility, in this section of the hall, benches are made by different types of wood, symbolizing different stages of life.

The bench made by birchwood in the "Birth" section symbolizes fertility. Often being the oldest tree in the wilderness, birches symbolize young trees can become a forest, and in many cultures in Eurasia, birchwood is often used to make cradles. Sitting on this birchwood bench, quietly admiring its beautiful wood grain as if touching its vigorous life history.

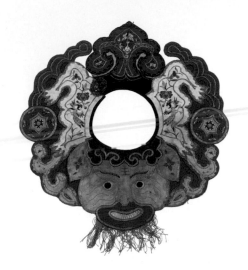

口圍

口圍又稱為涎水布，用來防止口水沾到衣服
上。老虎花樣有驅邪與守護的意涵，菊花紋飾
表達長壽之意，鼻眉呈金魚形，則有「金玉滿
堂」的意思。

Bib

Bibs are also called drooling bibs. They are used
to protect clothing from drooling stains. The tiger
patterns carry the meaning of protection. The
chrysanthemum decoration symbolizes longevity.
The nose and eyebrow area are shaped like a
goldfish, conveying a message of "prosperity."

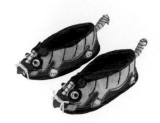

童鞋

這雙虎形童鞋以老虎作為造型，是借引虎威驅
邪或取其虎虎生風吉祥如意的意義。據說，穿
著虎鞋能使孩子走路時不容易跌倒。

Chinese Children's Shoes

This traditional Chinese pair of shoes have patterned
images of tigers. In traditional Chinese folklores,
tigers represent vigorous energy, good fortune, and
the ability to ward off evil, and this is exemplified in
the belief that tiger shoes can protect children from
falling while walking. Therefore, Chinese mothers
carefully sew tigers onto the shoes for their newborn
children, demonstrating deep love, affection and
hope.

苗族揹兒帶

苗族婦女從少女時期就開始製作揹兒帶，其蘊
含著對兒女的愛與期待。本作品是取材自「圍
腰」的揹兒帶，上繡許多代表祝福的符號。

Miao Baby Carrier

Miao women make baby carriers since their
girlhood. These handmade baby carriers represent
their love and expectations for their children. Inspired
by other baby carriers, this work is embroidered with
many symbols representing blessings.

成長 Coming of Age

生命最快速累積與成長的時程，揭示要脫離襁褓，面對獨立。需要勇氣，需要智慧，需要能力。我，在成形。

號稱連接天地的世界樹的梣木，是成長展區的長凳，感受到它挺拔嗎？在古代的北歐神話中，梣樹是連結天、地、地獄的「世界樹」，在神話中，第一個人類就是用梣木來造的，象徵了對年輕生命的祝福和美好期許。

In the most rapid accumulation and growth stage of life, people need to get out of their reach of family and face independence. It takes courage, wisdom, and ability. A solid personality is shaping.

The Ash tree, known as a "tree of the worlds" that connects heaven and earth in the ancient Scandinavian mythology, were chosen to make the bench in this section of the hall, and Ash tree has been the tree used to make the first human in the mythology. Ash wood has been representing the good wishes and hope for a young life.

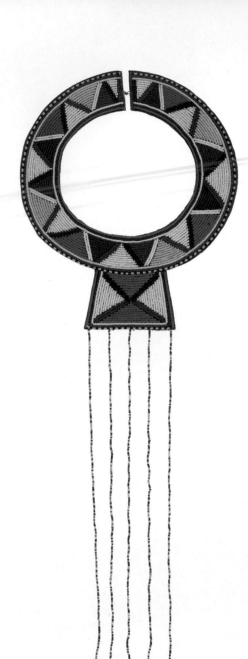

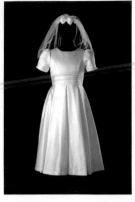

第一次領聖餐服

對於天主教家庭的小孩而言，第一次領聖餐是值得紀念的日子，表示他已明白彌撒的意義與麵包和葡萄酒所具有的基督犧牲奉獻意涵。

Christian First Communion Attire

Christian families regard a child's first communion day as a significant event. On this special occasion, parents eagerly undertake all the necessary arrangements for their child reached the age 7. This age is considered appropriate because it is believed that children reached the age 7 possess the capacity to comprehend the significance of the bread and wine in the Sacrament of the Eucharist.

泰雅族紋面工具組

泰雅族少男少女的紋面，是成年的標記，也是代表一個人能負擔社會責任，獨立自主。

Atayal Facial Tattoo Tool Set

The facial tattoos of the Atayal young boys and girls symbolize adulthood and represent a person who can afford social responsibility and independence.

馬薩伊族首飾

項圈是少女們用傳統技法製成，是馬薩伊族重要的裝飾品之一。

Maasai Jewelry

Traditional Maasai neckpieces were made by maidens using traditional techniques and are one of the important decorative items of the Maasai people.

中年 Mid – Life

撐起人的運行的生命階段，開
枝散葉，承先啟後，需要堅
毅，需要洞察，需要內省。也
許是能量的巔峰，也許影響的
更多群體，也許有更多的承
擔。意義，在構成。

以西洋杉製成的長凳，放在中
年展區，說它有多重象徵：神
聖、愛侶、奉獻、保護。你看
得到它的精彩嗎？

This is a significant part for a person's
life journey, and it brings most of its
meanings. It can be fruitful and bringing
offspring, and taking responsibilities,
being a bridge for the old and the
young. In this stage of life, people need
insights, wisdom, and introspection. In
this stage, people may be at the peak
of his or her energy, may be able to
affect others more, may have more
commitment. Meaning of life is in
shaping.

The bench in this section is made
of western fir, placed in the middle
age section, is said to have multiple
symbols: sacredness, love, dedication,
and protection. Can you see its
splendor?

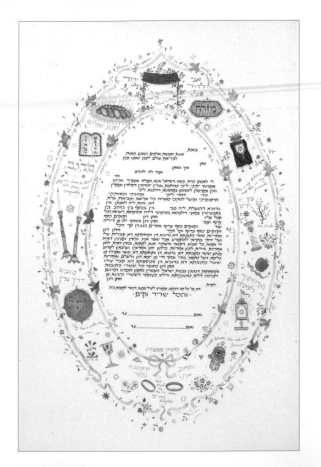

錫克教頭飾

此件頭飾代表卡爾薩教團的教徽，中央的雙刃劍，象徵信仰唯一真神與保護教團；兩邊的彎劍，則是代表精神與世俗的力量。

Sikh Headwear - Dastar

This headdress represents the emblem of the Khalsa (refers to both a community that considers Sikhism as its faith, as well as a special group of initiated Sikhs), with a double-edged sword in the center, symbolizing faith in the one true God and protection of the group, and curved swords on either side, representing spiritual and secular power.

聖索與硃砂盒

「聖索」是在印度傳統婚禮中使用的紅色棉線，象徵新人永遠的連繫並向眾神祈求賜與他們力量及好運。「硃砂盒」中裝有紅色礦物粉，儀式中新郎會沾取硃砂置於新娘的分髮線，表示夫妻之愛，並祈求婚姻的吉祥長久。

Hindu Holy Rope and Sindoor Box

The Holy Rope is a red thread used in traditional Indian weddings, symbolizing the eternal connection between the newly married couple. The Sindoor Box contains red powder, applied by the groom to the bride's hair parting as a symbol of love and prayers for a long and auspicious marriage.

猶太教婚約

婚約是猶太夫妻之間傳統的契約,律法書會列出丈夫對妻子的義務與權力，常繪有精美的裝飾圖案，成為夫妻珍藏的紀念品。

Jewish Marriage Contract - Ketubah

The Ketubah is a traditional contract between a Jewish husband and wife. It is considered an integral part of a traditional Jewish marriage, and outlines the rights and responsibilities of the groom to the bride. It is often decorated with intricate designs that becomes a treasured item for the couple.

老年 Old Age

難能可貴的存活者，知性與智慧的傳遞者。需要祝福，需要傳承，需要包容。對生命有體認，對內心有定見。生命，在實踐。

承載著古老的學問的山毛櫸做成的長凳在老年展區，有老學究的味道嗎？

Aged people are survivors, are transmitters of knowledge and wisdom. They need to be blessed, to be cared, and to be tolerated. In this stage of life, people tend to have a deeper understanding of life, an inner vision of self, and practiced one's understanding of life.

還曆祝著

在日本，為六十歲的人所舉行的儀式稱「還曆」。壽星穿上紅色衣帽，象徵回到初生或嬰兒期，回到一甲子的起頭，人生重新開始。

Shinto Kanreki Iwaigi

The Kanreki Iwaigi is a traditional garment worn by the Japanese on their 60th birthday. In Japan, at the end,of every 60 years is the beginning of a new cycle; therefore, turning 60 symbolizes a new beginning, a return to infancy, and a rebirth.

壽龜壽桃印模

在台灣，人們會準備糕點作為供品或節慶食品。而上方的圖案多有祈福、祝賀之意。龜與桃是長壽的象徵，遂以此印模製作祝壽的糕點。

Taiwanese Longevity Turtle and Cake Molds

In Taiwanese popular culture, special pastries are prepared for festivals and at sacrificial offerings for ceremonies such as New Year's, holidays, weddings, and funerals. Patterns on pastries have different meanings depending on the custom and occasion. For the most part, however, these patterns are used as a wish for good luck and health.

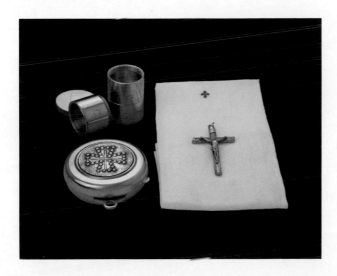

聖體盒與聖油瓶

天主教傅油禮所用。當教友生病臥床或臨終，以「聖油」擦敷身體，賦給聖寵，以減輕痛苦重振身心，或免除小罪，護送他們安抵天國。

Christian Pyx and Chrismatory

Pyx and Chrismatory are religious implements used in the Sacrament of Unction. When a Catholic is ill or close to death and is unable to attend Mass to receive the Sacrament of the Eucharist, a representative of the Church visits his or her home with a Pyx and Chrismatory to minister the sacrament. With the application of sacred oil on the communicant's face and limbs, the grace of God is received, relieving the person's mental and physical pain.

死亡及死後世界 Death and Afterlife

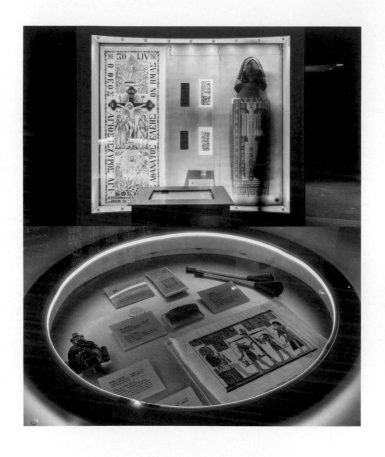

終將終止的生命，然後呢？那麼，生命初始之前是什麼呢？是從無，回到無嗎？就生命的歷程來說，並不是回到無，卻是留下生命的印記。在東亞人的文化中，我們總是習慣性地迴避「死亡」這兩個字，但是迴避不會使它遠離，對死亡的思考，正是為了更好地活著。許多宗教與文明所提示的死後的世界，也是對生的觀照。

這個展區的長凳由象徵死亡的榆樹製成，它被認為可以減緩腐化，常用於製作棺木，亦稱為沉睡之樹。你能感受到它的安靜和和緩嗎？坐在榆木長凳上，觀看影片中的各種宗教的葬禮儀式，給我們安靜的省思空間，思索或回答自己的內心所繫，為靈性的覺醒開啟啟程的大門。

The life will finally end, and then what's the next? Is it a return from nothing to nothing? In terms of the course of life, it is not a return to nothing, but a mark of life. In the culture of East Asians, we have always avoided the word "death", but avoidance does not make it far away. The world after death, as suggested by many religions and civilizations, is also a view of life.

The bench in this section is made from the elm tree, a symbol of death, which is thought to have an effect to slow down the decay and is often used to make coffins, this type of the tree is also known as the tree of slumber. Can you feel its tranquility and calmness? Sitting on the elm bench and watching the funeral rituals of various religions in the video gives us a quiet space to reflect, to contemplate or answer our own innermost thoughts, and to open the door to spiritual awakening.

經衣板

本件為印製用的木刻版，經衣是給亡魂使用的日常用品，在普渡時，將經衣紙錢供給孤魂，讓他們在他界可以更換日用品，以安撫亡魂。

Jingyi Plate

This is a woodcut plate for printing of Jingyi clothes (paper clothes given to cadavers for funerals or rites to departed souls). *Jingyi* clothes are daily necessities for the departed souls, and during the Pudu worship, *Jingyi* clothes are offered to lonely souls so that they can change their daily necessities in the other world, thus appeasing the departed souls.

天葬號角

西藏人有一種「天葬」習俗，即是將屍體分割由鷹類吃食。若死者業障太深老鷹不願吃食，天葬師會儀式性的示範後引號呼喚老鷹食屍。

Tibetan Sky Burial Bugle

Sky Burial is the Tibetan custom of cutting a deceased person's body in pieces for vultures to consume. Tibetans believe vultures prefer to eat the remains of the dead with good karma. So when the deceased is believed to have bad karma, a priest uses a bugle to call the vultures to eat the remains of the corpse.

亡者之書

古埃及人將其置於死者身邊，或繪於棺木和墓壁，以幫助他通過冥間的危險。畫面描述的是阿努比斯測量死者的心臟，托特則在旁記錄。

Name: Egyptian Book of the Dead

The Egyptian Book of the Dead is a scroll of prayers and incantations. The size and the content in each section of the book vary according to the amount of the scroll purchased. Book of the Dead can be placed next to the deceased or painted on the coffin or walls of the tomb. It was believed that Book of the Dead could help a person pass through the dangers of the underworld to Heaven safely.

生命覺醒區 Hall of Life's Journey

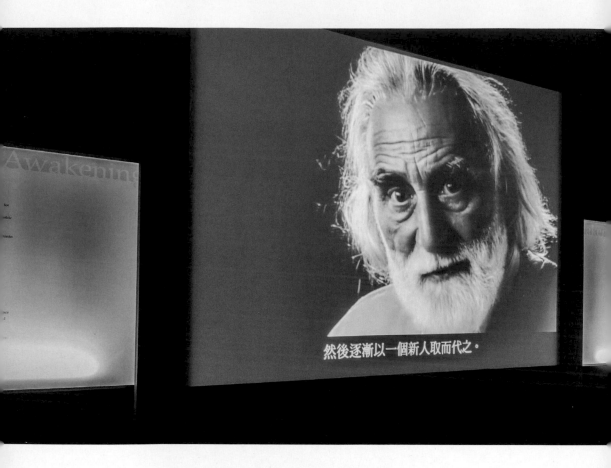

然後逐漸以一個新人取而代之。

每個生命都有其存在的意義，如果我們都有機會覺察到，或者我們能有機會感受到那個砥礪，某個助力，某個神來一筆，把它記錄下來吧，做為我是活生生的證明。

這裡，收錄了來自世界各角落不同信仰的精神領袖或是知名人士，通過訪談影片的方式，表述出自身生命中可貴的神聖時刻，或是在困難中破繭而出的深刻體驗，以此傳遞出人類生命與靈性的無限潛力。

在觀看之餘，也許你也會想到自己經歷過的一些特殊的震撼事件，或是某個富卜的感動，改變了自己的生命價值和觀點呢？

Every life has its own meaning. If we could realize it, or if we have the opportunity to feel it, with some kind of help, from God, then record it as a proof that being alive.

Here in this area, religious leaders, and celebrities of different faith traditions from all corners of the world are interviewed to express the precious sacred moments in their lives or the profound experience of awakening during difficulties, conveying the infinite potential of human life and spirituality.

While watching the interview, you may also think of some special shocking events you have experienced, or a momentary touch that has changed your own life values and perspectives?

靈修學習區 Meditation Gallery

全然地面對和瞭解自己

深層的自我對話，是對靈性的對話。靈修應該是各個文明與宗教都有的心靈活動，關乎於深奧且專注的思考。禪坐、禮拜、祈禱甚至太極拳，都可以是宗教中的靈修方式。

這個區域裡的影片介紹了各種靈修方式，參觀者也可以脫下鞋子，步上展廳中央的平台，調息吐納，平心靜氣，用自己的方式體驗內心而外的放鬆舒緩的過程。這個平台是楓樹所製，像是一張席地展開的地毯，你可以坐上，或是躺下，放鬆地和自己對話。

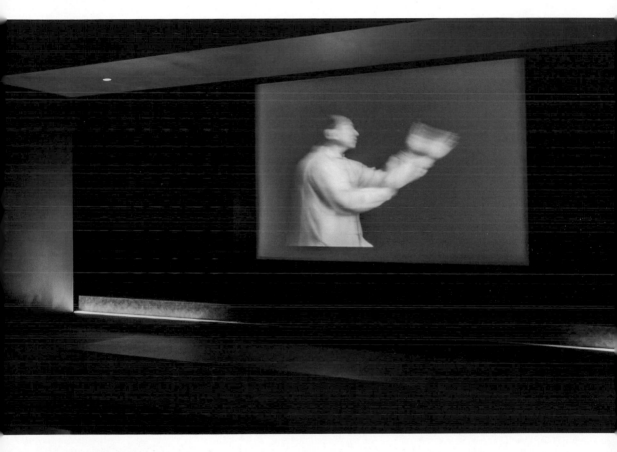

Facing and understanding ourselves

Dialogue with oneself in a deeper level is a spiritual activity and can be described as meditation. It can be found in all civilizations and religions, in the form of meditation, worship, prayer, and even Tai chi, they are all different forms of spirituality.

In this area, visitors are welcomed to remove their shoes and step onto the platform in the center of the room, where they can breathe in and out, calm their minds, and experience the process of inner and outer relaxation in his or her own way. The platform is made of maple wood and resembles a carpet spreads out on the floor, so you can sit on it or lie down and relax and have a deep inner dialogue to yourself.

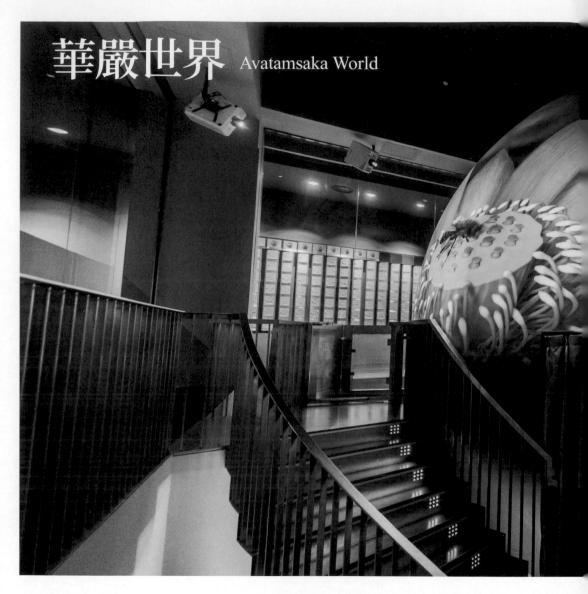

華嚴世界 Avatamsaka World

"一即一切，一切即一。"

生命歷程走完，進入球體建築。回頭望向生命之旅展廳，原來，每個展區的展示螢幕，那巧妙的弧形，正可組合成一個球體！意味著，每個生命，都是個華嚴珠玉之網上的寶玉。個體的經驗，個別的生命，終將編織出浩瀚的人類文明。這個文明的終端，是尊重，是包容，是靈性，是生態。

One is everything, and everything is one.

After the journey of life, we entered this sphere space. Looking back at the Hall of Life's Journey, it turns out that the ingenious curved shape of the screen in each section can be formed into a sphere! It is like that each life is a precious jewel in a web of magnificent jewels. Individual experiences, individual lives, will eventually weave a vast web of human civilization. At the core of this civilization, it is respect, tolerance, spirituality, and a balanced ecology.

匯聚

Converge

跨越時空，千百年宗教智慧匯聚一堂

Across time and space, different religious wisdom accumulated by thousands of years come together.

世界宗教展示大廳

Great Hall of World Religions

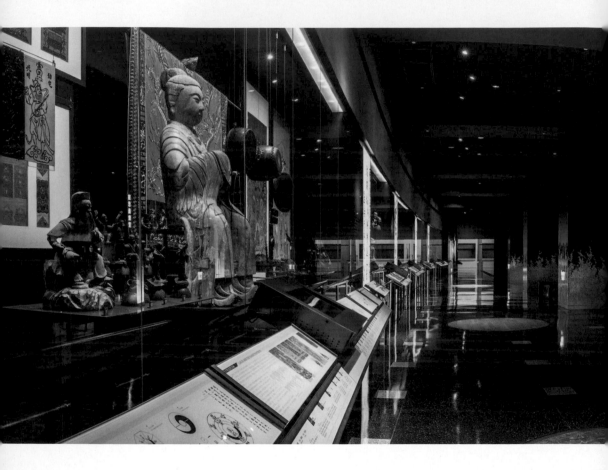

信仰與宗教，凝聚了人的善性，提示了人類共同的追尋，指向絕對的價值。千百年來，世界各地的人們得以突破生命的格局，前仆後繼地創造出藝術成就非凡的物件與器物，為的是彰顯和讚頌所尊崇的永世價值。這是宗教文物中最令人感動的面向。

我們在讚嘆宗教文物的工藝成就與藝術價值之餘，是否會察覺：宗教文物使人們的靈性得以富足，得到救贖的可能性？或者體悟到我們自身可與萬物平衡共存的世界觀呢？

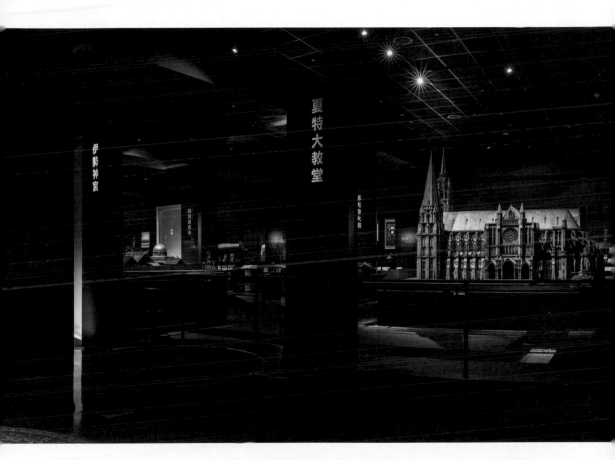

Faith traditions and religions can be seen as the crystallization of goodness in human nature. We can see many common aspects of human pursuits from these religions, and they can be a representation of value of human civilization as a whole. For thousands of years, people around the world have been able to break through the limits of life to create sacred objects and artifacts with extraordinary artistic achievement to highlight and celebrate the eternal values that are revered. This can be a very touching aspect of these objects.

While we marvel at the skill achievements and artistic value of religious artifacts, do we perceive the possibility of spiritual enrichment and redemption through religious artifacts? Or do we perceive a worldview in which we ourselves can coexist in balance with all other creatures?

古埃及 Ancient Egypt

相信死亡不是生命結束的多神體系
A polytheistic religious system that believes death is not the end of life

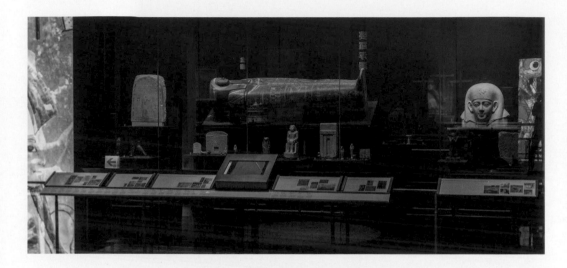

古埃及的宗教屬於古老的地區性的宗教，信仰群體早已不存，後來的人們多將其稱為古埃及神話。這種古代宗教的信仰核心是由一套複雜的多神信仰和宗教儀式所構成的，它是古埃及社會不可或缺的一部分。

古埃及人認為有許多神祇存在於世，且這些神祇能控制世界，人們需要通過祈禱和獻祭來獲得其庇佑。法老被認為是崇拜的重要一環，是人神合一的統治者。除法老之外，法老的守護神赫拉斯，赫拉斯之母伊西斯、冥界之神奧賽里斯都是古埃及宗教中的重要神祇。

Ancient Egyptian religion was an ancient regional religion. While adherents have long since died out and it no longer exists as a belief system practiced today, later generations have referred to it as ancient Egyptian mythology. At the core of this ancient religion is a complex system of polytheistic beliefs and religious rituals, and formed an integral part of ancient Egyptian society.

Ancient Egyptians believed in the existence of numerous deities who had control over the world. They believed that these gods and goddesses could bestow their blessings upon people, and individuals sought their blessings and protection through prayers and offerings. Pharaohs were considered a crucial part of the worship rites and were believed to be the embodiment of the divine and rulers who unified the realm of humankind and the gods. In addition to the pharaoh, the ancient Egyptian religion considered the following deities as important: Horus, the protector god of the pharaoh; Isis, the mother of Horus; Osiris, the god of the afterlife; and Bastet, the goddess of joy.

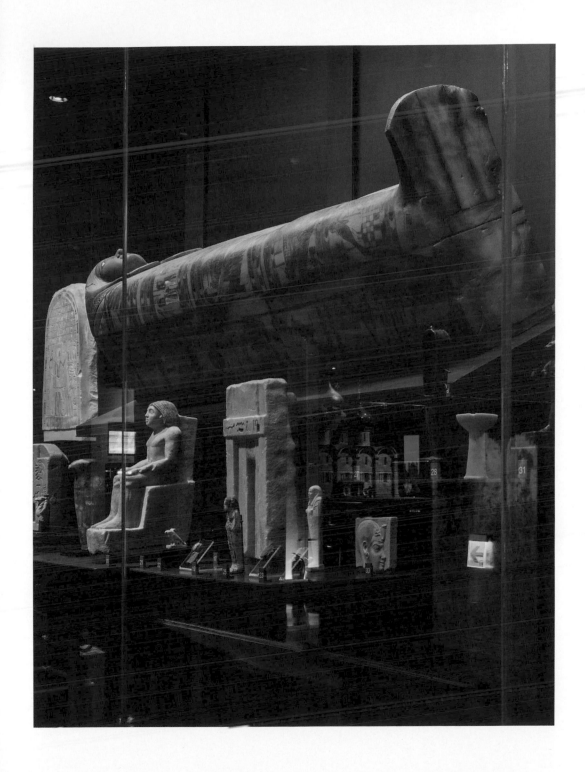

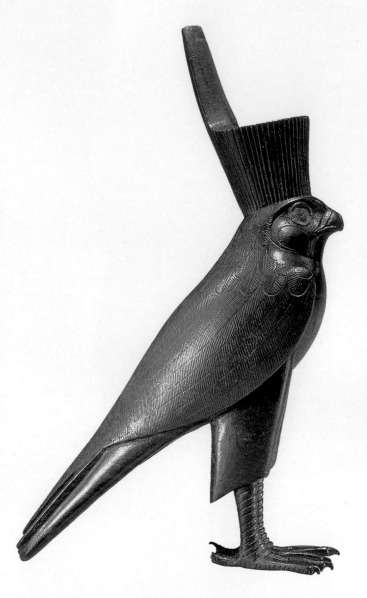

赫拉斯

材質：青銅
年代：西元前七世紀至四世紀
尺寸：5.8×20.8×12.5 公分

鷹隼形象的赫拉斯是古埃及信仰中的太陽神之一，代表日正當中的太陽，也是法老王權的象徵。赫拉斯頭上所戴的是象徵上下埃及統一的紅白兩色王冠。這一類的小型雕像常被置於赫拉斯神殿中，作為祭祀的獻祭品。

Horus

Material: Bronze
Era: 7th to 4th centuries BCE
Dimensions: 5.8×20.8×12.5 cm

Horus, usually depicted as a falcon-headed figure, was one of the sun gods in ancient Egyptian beliefs, representing the sun in the middle of the day, and a symbol of the pharaoh's power. Horus is usually depicted wearing a pschent, or a red and white crown, as a symbol of kingship over the entirety of Upper and Lower Egypt. Such small statues were often placed in the temple of Horus as sacrificial offerings.

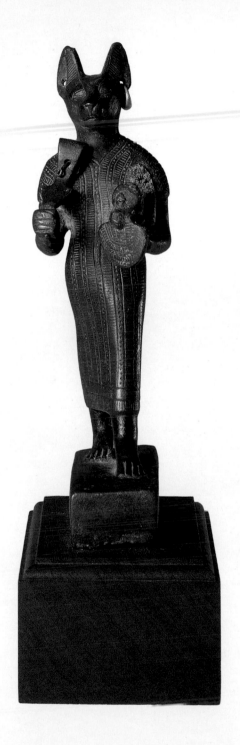

巴斯泰特

材質：青銅
年代：西元前七世紀至四世紀
尺寸：4.3×6.5×15.8 公分

巴斯泰特的外觀是貓頭人身的女神造型。在上下埃及的統一之前，她曾經是下埃及地區的戰爭女神，與之相對的是上埃及的獅子女神塞赫麥特，而因為貓和獅子的相似性，巴斯泰特的神職慢慢從戰神轉化成為了家庭的守護神，在古埃及晚期成為了十分受歡迎的神祇，被認作是歡樂之神，也是家宅的守護神。

Bastet

Material: Bronze
Era: 7th to 4th centuries BCE
Dimensions: 4.3×6.5×15.8 cm

Bastet is a goddess depicted with the head of a cat and a slender female body. Before the unification of Upper and Lower Egypt, she was once the goddess of war in Lower Egypt, in contrast with the lioness goddess Sekhmet of Upper Egypt. Due to the similarity between cats and lions, the role of Bastet gradually transformed from a war deity to the protector of households. In the Late Period of Egypt (525-332 BCE), she became a highly popular deity, regarded as the goddess of joy and the guardian of the home.

馬雅 Maya

融合了他教精神的自然崇拜
Nature worship that incorporates the spirit of other religions

我們所稱的馬雅人（Mayans）主要是分布在中美洲一帶，他們在這裡繁衍生活的歷史已超過三千年。至今尚有數百處馬雅文明遺址分布在中南美洲。

現代馬雅人雖然還在舉行宗教儀式，但是隨著馬雅文化的消逝，早期馬雅人的宗教精神也大多遺落在了歷史中。外來文化的入侵對馬雅人的宗教構成了嚴重威脅，但是馬雅人的宗教並沒有完全消失，而是融合了天主教精神和圖騰，顯現了原住民宗教的生命力。

The Mayans, as we call them, are mainly found in Central America, where they have been living for more than 3,000 years. There are still hundreds of Mayan civilization sites in Central and South America.
Although the Mayans still practice religious rituals today, much of the early Mayan religious spirit has been lost as the Mayan cultures' decline. The invasion of foreign cultures posed a serious threat to the Maya religion, but the Maya religion has not disappeared completely, but has integrated the Catholic spirit and totems to reveal the vitality of the indigenous religion.

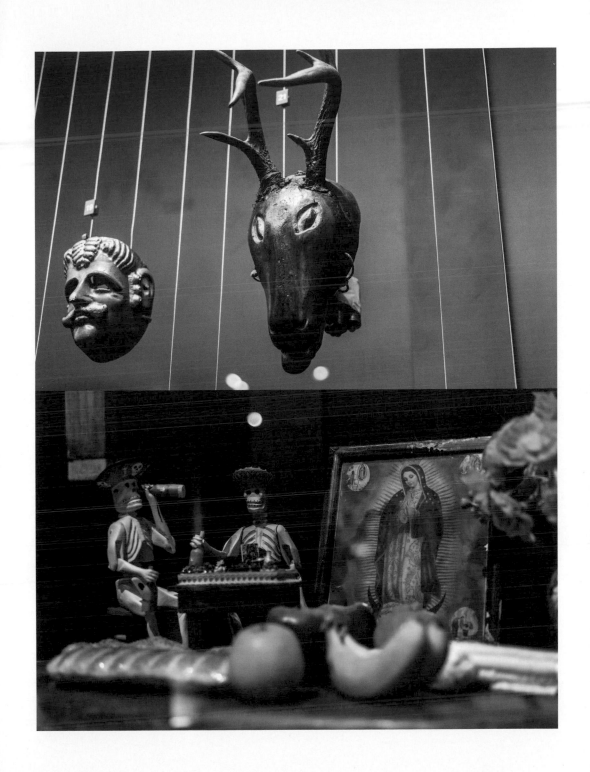

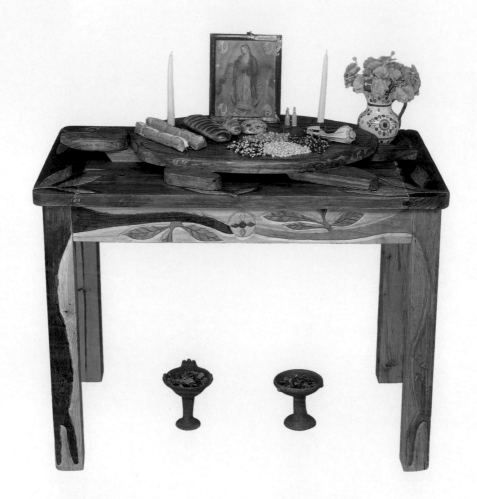

馬雅祭壇

材質：松木
年代：西元二十一世紀
尺寸：120✕95✕75 公分

這個祭壇來自於墨西哥的恰帕斯，這裡存在大量馬雅文明的遺跡。當進行「亡者之日」的儀式時，祭壇就會放置供品，上面的裝飾紋樣則體現了原住民和基督宗教的融合。

Mayan Altar

Material: Pine
Era: 21th century CE
Dimensions: 120✕95✕75 cm

This religious altar originated from Chiapas, Mexico, where there are numerous remnants of the Mayan civilization. When the Día de Muertos (Day of the Dead) ceremony is performed, offerings are placed on the altar and the decorative patterns on it reflect the fusion of indigenous and Christian religions.

垂掛型織品

材質：棉
年代：西元二十一世紀
尺寸：40.5×72×0.1 公分

這個垂掛型紡織品正處在製作的
過程中，可以顯現出墨西哥恰帕
斯州的編織型態，它顏色連裡，
圖樣複雜，是恰帕斯高地紡織品
中的精品。

Hanging textile

Material: Cotton
Era: 21th century CE
Dimensions: 40.5×72×0.1cm

This draped textile is in the weaving
process and reveals the characteristic
patterns of Chiapas, Mexico. With
its continuous colors and intricate
patterns, it is considered among the
finest examples of textiles from the
Chiapas Highlands.

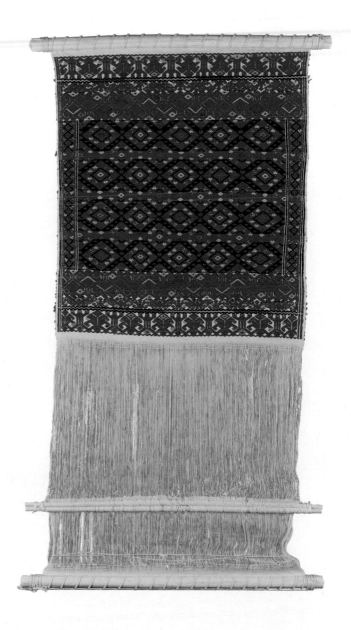

猶太教 Judaism

遵守與上帝間特殊誓約的選民
God's covenant with his chosen people

猶太人的信仰、價值觀和傳統生活方式一般被稱為猶太教。猶太教是一神論的宗教，它主要經典是包括妥拉在內的塔納赫（即希伯來聖經），以及包括口傳律法、口傳律法註釋以及聖經註釋在內的塔木德。對信奉猶太教的猶太人而言，猶太教是上帝和以色列人立約的關係。

猶太教以希伯來聖經為根本經典，基本教義是相信神是創天造地的，獨一的。猶太人要尊崇唯一的、超越一切的神，而且要嚴守上帝給摩西頒布的禁止偶像崇拜，守安息日的十誡和律法。

Jewish beliefs, values and traditional lifestyles are generally referred to as Judaism. Judaism is a monotheistic religion whose main scriptures are the Tanakh (Hebrew Bible) and the Talmud. The Tanakh includes the Torah (i.e., Five Books of Moses, or Pentateuch), and the Talmud are formed by the Oral Torah (Mishnah), the commentary and interpretations on the Mishnah (Gemara), and the interpretations on spiritual text (Midrash). For practicing Jews, Judaism is the basis for the covenant between God and the chosen people of Israel.

The basic doctrine of Judaism is the belief that God is the creator of the heavens and the earth, and is the one and only true God. The Jewish people are required to worship the one and transcendent God, and they must strictly observe the prohibition of idol worship that God commanded to Moses, as well as the obligation to observe the Ten Commandments and the laws regarding the Sabbath.

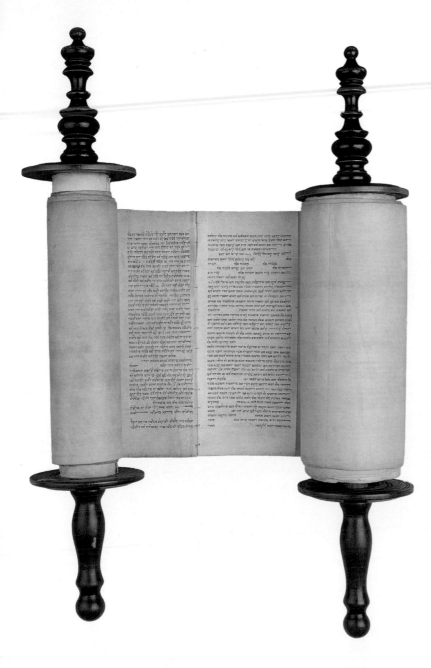

猶太律法

材質：木、羊皮紙
年代：西元十九世紀
尺寸：
58.7 ✕ 2423.5 ✕ 11.1公分

猶太教中最重要的經典就
是被稱為「Sefer Torah」
的猶太聖典。它的內容中
包含有摩西五經。這一本
聖典製作於西元十九世
紀，由經文抄寫者由右至
左抄寫在羊皮紙上。在猶
太會堂舉行禮拜時，它會
被高舉誦讀，隨後收藏在
罩布或是律法匣裡。對猶
太教徒而言，抄寫和製作
妥拉的書卷軸也是履行613
條戒律的其中之一。

Torah

Material: Wood, parchment
Era: 19th century CE
Dimensions:
58.7 ✕ 2423.5 ✕ 11.1cm

The most important text in
Judaism is the Jewish canon
known as "Sefer Torah". It
contains the Five Books
of Moses. This Torah was
made in the 19th century
CE, and copied from right
to left on parchment by a
scribe. It is read aloud during
a synagogue service and is
then stored in a covering or
a Holy Ark (cabinet used to
store the Torah). For religious
Jews, copying and making
scrolls of the Torah is one of
the 613 Commandments to
fulfill.

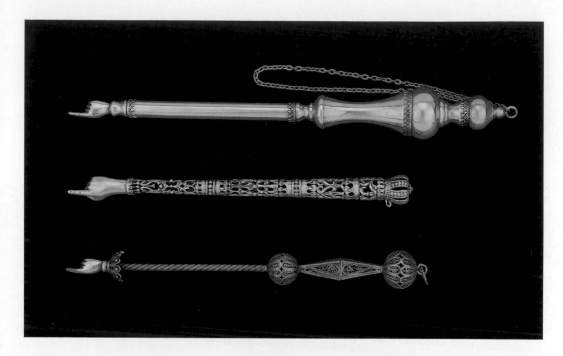

指經棒

材質：銀
年代：西元二十世紀
尺寸：41×3.1×3.1 公分

在希伯來文中，指經棒的唸法是
「yad」，意思是「手」。它是用在猶
太教的一種儀式用品，在誦讀羊皮紙
做成的經卷過程中，用指經棒指著上
面的文字誦讀。這樣做是為了確保人
們在閱讀過程中不會碰觸到羊皮紙，
因為經文被認為是來自於神的語言，
以手觸碰會引來儀式性潔淨的考量。
另外，羊皮紙十分脆弱，而且有的羊
皮紙材質不吸收墨水，以手指觸碰會
造成字跡的損傷。因此在誦讀妥拉
時，猶太教徒常常使用這種指經棒。

Yad

Material: Silver
Era: Era: 20th century CE
Dimensions: 41×3.1×3.1cm

In Hebrew, the word "yad" refers to the ritual
rod, popularly known as a Torah pointer, literally
means a "hand". It is a ritual object used in
Judaism during the recitation of a religious
scroll made of parchment by pointing to the
words on it with a yad. This is to ensure that the
reader does not touch the parchment during
the recitation process, as holy scriptures are
considered to be in the language of God
and touching them with the hands invokes
concerns about ritual cleansing. Furthermore,
parchment paper is very fragile, and some
parchment paper material does not absorb ink;
therefore, touching the parchment will cause
damage to the writing. For this reason, Jews
often use a yad when reciting the Torah.

律法之冠

材質：銀
年代：西元二十世紀初
尺寸：49×28×18.5公分

律法之冠中的「律法」在這裡指代的是妥拉（Torah）。在猶太會堂舉行的禮拜儀式時，律法書會從這個華美的皇冠上取下。因為在猶太教的信仰中，妥拉是來自於神的話語，它本身高貴無比，就像是象徵無上王權的皇冠一般。這一件館藏的律法之冠製作於西元二十世紀初的波蘭，以白銀製成，可以套在連結在妥拉的木捲軸上。在王冠的四周，可以看到鈴鐺，這些鈴鐺會在妥拉被取出時發出聲音，以表示妥拉被取出。

Torah Crown

Material: Silver
Era: 20th century CE
Dimensions:
49×28×18.5cm

The word "Torah" in Torah Crown refers to the Torah. The Torah is removed from this magnificent crown during the worship service in a synagogue. For in the Jewish faith, Torah is considered the word of God, which in itself is as noble as a crown symbolizing supreme authority above all else. Made in the early 20th century CE in Poland, this Torah crown in the museum collection is made of silver and fits over a wooden scroll attached to a Torah. One can observe bells adorning all sides of the crown. These bells make a sound when Torah is taken out to indicate that Torah has been taken out.

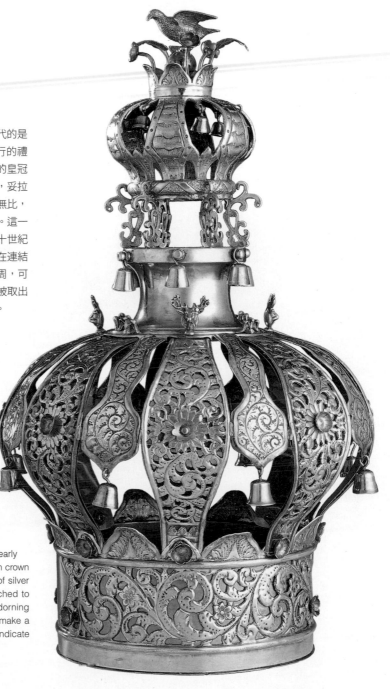

基督宗教 Christianity

以聖體、聖血與神立下新的盟約
A new covenant with God in the Holy Communion and the Holy Blood

基督宗教起源自巴勒斯坦，相信耶穌誕生、傳道、死亡、復活和升天等事蹟，是信仰耶穌基督是上帝之子與救世主（彌賽亞）的宗教，本館使用「基督宗教」這一名詞來概括信仰耶穌基督為上帝之子的宗教。

基督徒所相信的基本教義是三一論、基督論、救恩論。三一論強調聖父、聖子和聖靈一而三、三而一的奧秘；基督論是說耶穌身上同時並存人性與神性，是眼目不可見的上帝在地上真實的彰顯；救恩論則是指耶穌在十字架上作為人類罪債的贖價，挽回人與上帝之間因罪而破裂的關係。

Christianity is a religion that believes in Jesus Christ as the Son of God and Savior (Messiah). In this book, the term "Christianity" is used to describe the faith traditions which believe in Jesus Christ as the Son of God.

The basic doctrines that Christians believe in are the Trinity, Christology, and Salvation. Trinitarian doctrine emphasizes the sanctity of the Father, the Son of God, and the Holy Spirit as three distinct persons (hypostases) sharing one essence/substance/nature (homoousion). Christology doctrine refers to the coexistence of the human and divine natures in Jesus Christ, the true manifestation of the invisible God on earth, i.e., the incarnation. Salvation refers to the belief that Jesus dying on the cross was the sacrifice necessary to redeem the sins of humankind, redeeming the broken relationship between man and God.

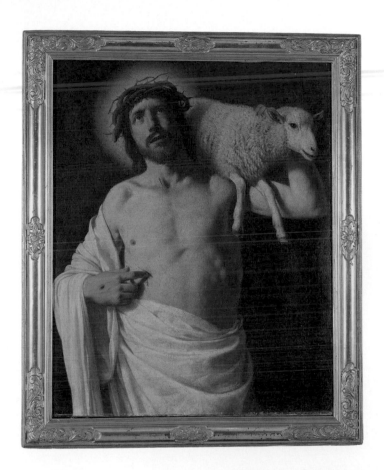

牧羊人耶穌

材質：油畫布，顏料
年代：西元十七世紀
尺寸：99.7×69.8公分

這幅油畫被認為是出自法國畫家菲利普·德·尚帕涅（Philippe de Champaigne）之手。牧羊人將羊背負在肩膀上的「好牧人」的題材在基督宗教中象徵「耶穌基督」；耶穌曾自比好牧人，照顧子民，甚至可以犧牲自己的生命。這一牧羊人的比喻出自《路加福音》第十五章中耶穌講的三個比喻中的一個。

Jesus the Shepherd

Material: Canvas, pigment
Era: 17th century CE
Dimensions: 99.7×69.8cm

This painting is attributed to the French painter Philippe de Champaigne. The theme of the "Good Shepherd" who carries the sheep on his shoulders is emblematic of "Jesus Christ" in the Christian religion; Jesus once compared himself to the Good Shepherd who takes care of his people and may even sacrifice his own life. The Parable of the Lost Sheep is one of the parables of Jesus as described in Luke 15.

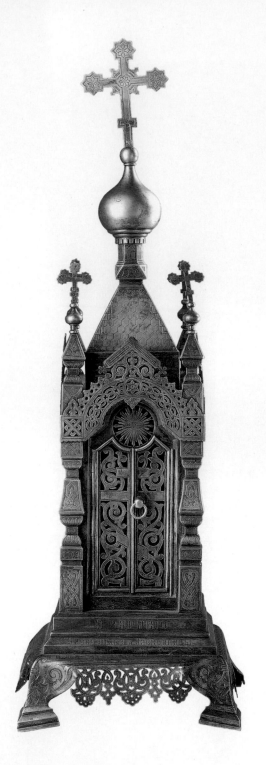

耶穌聖體櫃

材質：銅
年代：西元十九世紀
尺寸：17.7 ╳ 54.5 ╳ 18.1 公分

這座聖體櫃是教會用於放置聖餐中的聖體的地方。除了放置聖體的地方之外，這個聖體櫃的四周也有繁複美麗的雕刻花紋。整個聖體櫃是以東正教教堂的形式呈現的，正面大門為取放聖體碟和聖餐杯的入口，其他三面分別是描繪了耶穌在橄欖山上祈禱、耶穌受審、耶穌升天的浮雕。

Tabernacle

Material: Copper
Era: 19th century CE
Dimensions: 17.7 ╳ 54.5 ╳ 18.1cm

This tabernacle house is a box in which the Eucharist (consecrated communion hosts) is stored. In addition to being the place where the Eucharist is placed, this tabernacle is adorned with intricate and beautiful carvings. The entire tabernacle is presented in the form of an Orthodox church, with the front door being the entrance to the Eucharist and a communion cup, and the other three sides depicting Jesus praying on the Mount of Olives, Jesus on trial, and Jesus ascending to heaven in relief form.

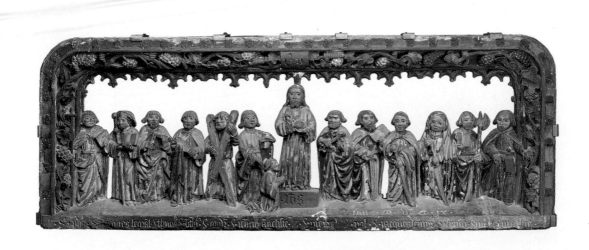

耶穌與十二使徒雕刻

材質：石膏
年代：西元十七世紀
尺寸：179×66 公分

這件文物來自西班牙，描繪的是耶穌
與十二使徒。藉由人物姿態、文字和
他們的手持物件，可以得知位居中央
的是耶穌，十二使徒各立於兩側。從
觀眾視角來看，從右至左分別為馬
太、達太、奮銳黨的西門、亞勒腓的
兒子雅各、保羅、彼得。從左至右的
分別是，腓力、雅各、多馬、巴多羅
買、安德烈和約翰。有趣的是，製作
它的工匠也將一位基督教信徒的形象
放在了耶穌的腳下。

Sculpture of Jesus and the Twelve Apostles

Material: Plaster
Era: 17th century CE
Dimensions: 179×66cm

This artifact originated in Spain and depicts
Jesus and the Twelve Apostles. By observing
the posture of the figures, the text, and the five
objects they hold, it is clear that Jesus is in the
center, with the twelve apostles standing on
either side. From the perspective of the viewer,
from right to left, the figures are identified
as Matthew, Thaddeus, Simon the Zealot,
James son of Alphaeus, Paul, and Peter. From
left to right, they are Philip, James, Thomas,
Bartholomew, Andrew, and John. Interestingly,
the craftsman who made it also placed a figure
of a Christian believer at the feet of Jesus.

伊斯蘭教 Islam

順服真主律法的追隨者
Followers who obey the laws of Allah.

阿拉伯語的「伊斯蘭」，意指「順從」或「屈服」於獨一無二的造物主和宇宙萬物的主宰之下。穆罕默德‧伊賓‧阿布杜拉，透過天使長吉卜利里，接受來自真主的啟示，奉命召集人們信仰伊斯蘭教，與將其所得之啟示匯集成伊斯蘭的經典《古蘭經》，此經典被視為是真主賜予人類的最終亦是最佳的根本指南。穆罕默德被尊為是最初、也是最具權威的《古蘭經》詮釋者。透過《古蘭經》與先知穆罕默德的言行典範《聖訓》，穆斯林不斷地發展出多樣且複雜的方式接近真主和解釋神之旨意。

The Arabic word "Islam" means submit to the one and only Creator and Lord of the universe. Muhammad ibn Abdullah received a revelation from God through the Archangel Jibril and was instructed to gather people to Islam and to integrate the revelations he received into the Qur'an, the Islamic scripture, which is considered the ultimate and best fundamental guide from God to mankind. Prophet Muhammad is revered as the original and most authoritative interpreter of the Qur'an. Through the Qur'an and the Sunnah, the example of the Prophet Muhammad's words and deeds, Muslims have continued to develop diverse and complex ways of approaching God and interpreting His will.

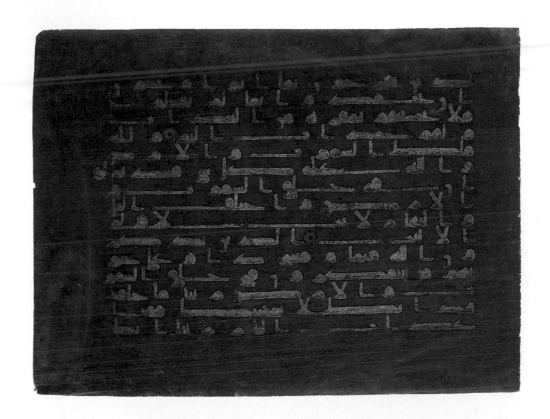

大型古蘭經書頁（藍色古蘭經）

材質：羊皮紙、泥金、靛藍染料
年代：西元九-十世紀
尺寸：28.7 × 38.2 公分

這張藍色的古蘭經書頁是本館典藏中的珍品，距今已有超過一千年的歷史。這張古蘭經書頁來自於地中海沿岸地區，經過周全的版面設計，以金抄寫在羊皮紙上。它的書法字體是相當古樸的庫法體（Kufic script），抄寫了古蘭經文（3:187-194）。從較少華麗裝飾，但是版面安排整齊劃一的十五行庫法體文字看來，這是早期古蘭經抄本中的精彩實例。

Qur'an Page (Blue Quran)

Material: Parchment, gold, indigo dye
Era: 9th to 10th century CE
Dimensions: 28.7 × 38.2 cm

This blue Qur'an page is one of the greatest treasures of our museum's collection, and it is over a thousand years old. This page from the Quran originates from the coastal regions of the Mediterranean. It has a well-planned layout design and has been meticulously transcribed in gold on parchment paper. The calligraphic script used in this Qur'an page is classical Kufic script. It beautifully transcribes verses from the Quran (3:187-194). From the relatively less ornate decorations and the neat arrangement of the text in fifteen lines of Kufic script, it appears to be a valuable example of early Qur'an manuscript.

天房罩幕

材質：棉和絲
年代：西元二十世紀
尺寸：**166.2×62.5×0.9公分**

去聖地麥加朝覲是伊斯蘭信仰的五項基本
功修之一，是有條件完成朝覲的成年穆斯
林的義務。聖地麥加的中心是位於禁寺內
的天房（克爾白）。天房四周都覆蓋有黑
色錦緞罩幕。每年在朝覲期間，沙烏地阿
拉伯王室會舉行洗滌和更換罩幕的儀式。
本館收藏的天房罩幕紡織物受贈於世界回
盟（Muslim World League），上面有金線
刺繡的古蘭經經文（20:82）：我必饒恕那
悔罪，歸信且行善，而且謹守正道的人。

Kiswa of Ka'ba

Material: Cotton and silk
Era: 20th century CE
Dimensions: 166.2×62.5×0.9 cm

Pilgrimage to Mecca, the holy city, is one of the five
pillars of Islam central to the Muslim faith; it is an
obligation for all able adult Muslims to complete the Hajj
at least once within their lifetime. The center of the holy
city is the Ka'ba located in the Grand Mosque (Masjid
al-Haram). The entire Ka'ba is covered with a black
satin curtain (Kiswa). Every year during the Hajj season,
the Saudi royal family performs the process of cleaning
and replacing the Kiswa. The Kiswa in our museum
collection is a gift from the Muslim World League. The
Quranic verse (20:82) embroidered with gold thread can
be translated as: God says, I am truly Most Forgiving
to whoever repents, believes, and does good, then
persists on the guidance.

古蘭經架

材質：木
年代：西元二十世紀
尺寸：50×21.5×27公分（展開）

這一個古蘭經書架，是以埃及、敘利亞一帶的傳統木器鑲嵌的紋飾風格及工藝製作完成的。展開後的書架用於擺放古蘭經，從而方便穆斯林坐在地面或地毯上虔心誦讀經文。古蘭經被穆斯林視作無上的貴重經典，記錄的是神的話語。因此，穆斯林十分重視和尊重古蘭經，不會將其放置在地面或是有不潔之虞的地方。這樣可折疊的書架就成為了清真寺和穆斯林家中常見的物品。

Quran Stand

Material: Wood
Era: 20th century CE
Dimensions: 50×21.5×27 cm
(when fully expanded)

This Qur'an stand is made in the traditional style of woodcraft and inlay patterns from Egypt and Syria. It showcases the craftsmanship and artistry of the region. The foldable book stand is used to place the book of Qur'an, enabling Muslims to sit on the ground or carpet and recite the scriptures devoutly. The Qur'an is considered by Muslims to be the most precious book recording the word of Allah. Therefore, Muslims value and respect the Qur'an and do not place it on the ground or in places where it may be considered unclean. In this way, foldable stands have become a common item in mosques and Muslim households.

印度教 Hinduism

創造、保護與破壞共存的宇宙觀
A worldview of the cycle of creation, preservation, and destruction

印度教徒相信「梵」是一切事物的基礎法則，其無法被表述或展現，上至諸神下至眾生皆是自梵而生，也同時體現了部分之「梵」，人的內在有著不滅的靈魂「我」，其會永恆的在輪迴之中轉世再生，在世時行善或行惡所造之「業」皆會影響重生時的優劣。但若能業、智與虔信等三條無私的道路之中擇一遵循，則能從自我與輪迴之中解放，也因此，印度教徒多稱自身的信仰為「永恆之法」，意即透過印度教中闡述的諸多「法」的實踐來獲得美好的來生或達成「梵我合一」的理想境界，得到解脫。

Hindus hold that "Brahman," which cannot be characterized or manifested, is the fundamental principle underlying all things. Every living thing, including the highest gods, is a manifestation of Brahman and bears a portion of it. An immortal soul known as the "atman" exists within people and experiences endless cycles of rebirth. The quality of a person's subsequent rebirths will depend on their life's "karma," or good or bad deeds. The cycle of self and rebirth can be broken by choosing one of the three selfless paths of karma, jnana, or bhakti. Because of this, many Hindus refer to their religion as the "Sanatana Dharma," believing that by abiding by the various "Dharma" it outlines, they can either improve their afterlife or reach the ideal state of "union with Brahman" and be liberated.

梵天

材質：砂岩
年代：西元十五世紀
尺寸：40 × 74 × 16.5 公分

梵天是宇宙創造神，和守護神毘濕奴、
毀滅神濕婆並稱三神。梵天有四首，分
別面對東南西北四個方向，四隻手分持
吠陀、蓮花、念珠和缽，此像因其浮雕
形式而僅見三首，手持念珠與缽，兩側
體型較小的神為梵天的追隨者。

Brahmã

Material: Sandstone
Era: 15th century CE
Dimensions: 40 × 74 × 16.5 cm

Along with Vishnu, the preserver, and Shiva,
the destroyer, Brahma, the creator god of
the universe, is regarded as one of the three
deities. There are four faces on Brahma,
each of which faces one of the four cardinal
directions. He has the Vedas, a lotus flower,
prayer beads, and a bowl for alms in each
of his four hands. Only three faces of
Brahma are shown in this sculpture due to
its relief form, each holding a bowl for alms
and prayer beads. The smaller figures to the
sides represent Brahma's devotees.

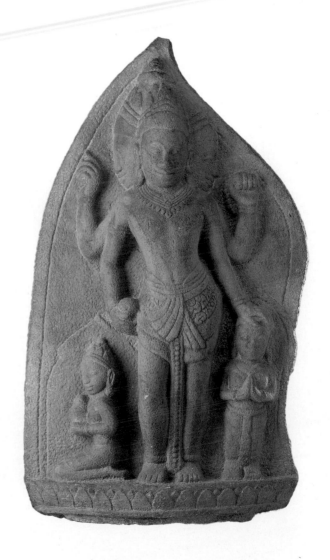

毘濕奴雕像

材質：花崗岩
年代：西元九世紀
尺寸：33×96.5×17.5 公分

毘濕奴為印度教三大主神之一。祂是現世世界的維護者及宇宙萬物的保護者，具有多種多樣的化身且無處不在而有「遍在者」之名。祂的手分別拿著：海螺，象徵起始的第一個音「唵」，宇宙萬物由此而生；法輪，代表季節及時間的循環；權杖，象徵知識與心靈的力量。象徵物的意象代表毘濕奴保護宇宙所需之能。

Vishnu

Material: Granite
Era: 9th century CE
Dimensions: 33×96.5×17.5 cm

Vishnu is one of the three main deities of Hinduism. Vishnu is the preserver of the earthly world and the protector of all beings in the universe. He has multiple incarnations and is omnipresent, known as the "All-Pervading One." Vishnu's hands hold various objects: a conch shell (Shankha), symbolizing the primordial sound of creation "Om", from which the universe emerges; a divine wheel of dharma (Dharmachakra), representing the cyclical nature of seasons and time; and a mace (Kaumodaki), symbolizing the power of knowledge and spirituality. The symbolic representation of these objects embodies the power required by Vishnu to protect the universe.

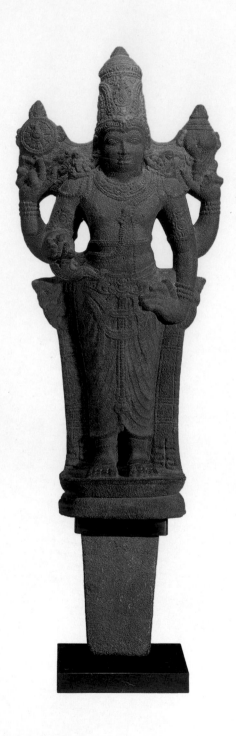

永恆的濕婆神

材質：黑石
年代：西元十二世紀
尺寸：22.6 ✕ 54.5 ✕ 8 公分

濕婆神為印度教三大主神之一，為宇宙
毀滅之神與舞蹈之神。祂同時具備創
造、繁衍與毀滅等三種權能，因此常被
描繪為三首的形象，眉間第三隻眼可在
宇宙的毀滅期到來之時，噴出神火以消
滅眾神與眾生；與右側之手所持之棍棒
和三叉戟等破壞的象徵相對應，左側之
手同時持有能以鼓聲創造新生的雙面
鼓，象徵其兼具破壞恐怖與復甦生機兩
極化之神格。

The Eternal Shiva

Material: Black Schist
Era: 12th century CE
Dimensions: 22.6 ✕ 54.5 ✕ 8 cm

Shiva is one of the three main Hindu deities,
the god of destruction and the god of
dance. Shiva possesses the three powers
of creation, procreation, and destruction,
and is often depicted with three heads to
represent this. The third eye on his forehead
can emit divine fire during the period of
destruction, annihilating gods and beings.
His right hand holds symbols of destruction
such as a club and trident, while his left
hand simultaneously holds a double-sided
drum capable of creating new life through its
sound. This epitomizes Shiva's dual nature
of both destructive terror and regenerative
hope.

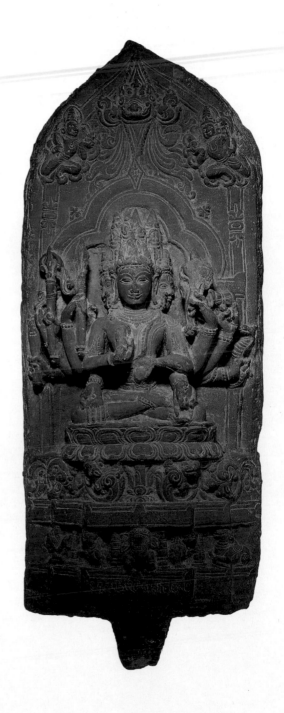

佛教 Buddhism

追求悟證之人的身影而修行
Pursuing the path of enlightenment and awakening in spiritual practice

佛教是指由原名悉達多‧喬達摩的釋迦牟尼佛所創的宗教信仰，以佛陀一生的言行教導作為核心思想，引領人們透過內心的修煉來脫離痛苦，追求內心的平靜。佛陀的教導指出眾生困於六道輪迴之中，命中皆充滿了苦難，而此諸多苦果皆源自於眾生受「貪、瞋、癡」三毒的驅使而造之業，信徒可在「三寶」—佛、法、僧的引領下，依循「八正道」原則修持自身，則能滅盡諸苦，達「涅槃」境界，得以從慾望和生死苦痛的輪迴束縛中解脫，是信徒實踐的終極目標。

Buddhism is a faith tradition based on the teachings of Siddhartha Gautama, also known as Shakyamuni Buddha. It takes the teachings and actions of Buddha as its core philosophy, guiding people to attain liberation from suffering and seek inner peace through inner enlightenment.
The Buddha is also known as the "Awakened One" or "Enlightened One", meaning the one who has attained the supreme enlightenment, who is able to understand the nature of life and guide beings on the right path to follow. The teachings of the Buddha point out that sentient beings are trapped in the cycle of birth, death, and rebirth (samsara), where existence is filled with suffering. This suffering arises from the actions driven by the three poisons (or three unwholesome roots) of attachment, aversion, and ignorance. Under the guidance of the Triple Jewels of Buddhism —Buddha, Dharma, and Sangha—followers can practice and follow the principles of the Noble Eightfold Path. By doing so, they can extinguish all suffering, reach the state of Nirvana, and liberate themselves from the bondage of desires and the painful cycle of samsara. This is the ultimate goal of Buddhist practitioners.

佛三尊造像碑

材質：石灰岩
年代：西魏大統八年
尺寸：36.2×73.5×15.1 公分

佛三尊造像碑為西魏紀年造像石碑；佛三尊
係指一佛二脅侍菩薩，是南北朝常見的造像
形式，佛著褒衣博帶，採結跏趺坐，左手
與願印象徵滿足眾生所願，右手無畏印象徵
布施無怖與安寧，脅侍菩薩身側的獅子為象
徵佛之無畏與偉大之意；背面亦刻有浮雕，
分上中下三層，上為飛天以歌舞鮮花供養諸
佛，中為佛陀、文殊和維摩詰，下為供養人
邑子與銘文，文中敘述佛弟子趙景與其家人
為皇帝及蒼生同得安樂造此碑。

Buddhist Triad Stele

Material: Limestone
Era: 8th year of the Datong reign of the
Western Wei Dynasty (542 CE)
Dimensions: 36.2×73.5×15.1 cm

The "Buddhist Triad Statue Stele" is a stone
monument dating back to the Western Wei
dynasty. The term "Buddhist Triad" refers to a
representation of one Buddha and two attendant
Bodhisattvas, a common form of sculpture during
the Southern and Northern Wei Dynasties. The
Buddha is depicted wearing draped robes and
sitting in the lotus position (Padmasana). The left
hand is in a gesture symbolizing the fulfillment of
the wishes of beings, while the right hand is in a gesture of fearlessness, representing the bestowal of generosity and tranquility.
The lions positioned beside the Bodhisattvas symbolize the Buddha's fearlessness and greatness. The back of the stele is also
carved with reliefs divided into three layers: upper, middle, and lower. The upper layer depicts celestial beings offering flowers
and performing dances to worship the Buddhas. The middle layer depicts the Buddha, Manjushri, and Vimalakirti. The lower layer
depicts the patron (Yi Zi) and an inscription. The inscription narrates how Zhao Jing, a believer of the Buddha, and his family,
offered this monument to bring peace and happiness to the emperor and all beings.

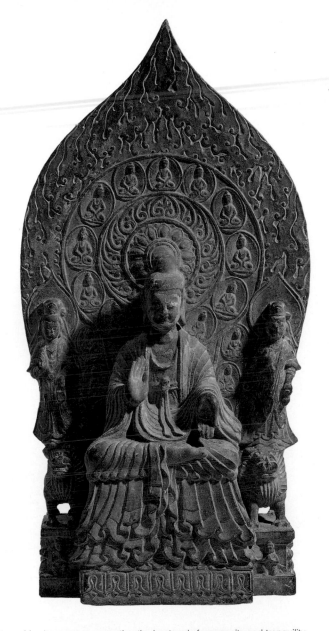

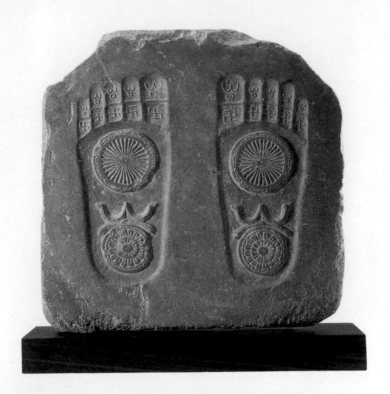

佛足石

材質：灰色片岩
年代：西元二世紀
尺寸：45.7×45.5×8 公分

印度之早期佛教，在寫實地描繪佛陀
形象的風氣尚未形成前，印度的早期
佛教常常以佛足石為象徵佛陀或其所
在之標誌之一，上有多種具特殊宗教
意涵的紋飾，卍字為佛教中常見的吉
祥符號，也象徵佛之清淨圓滿，有三
個尖端的符號代表佛法僧三寶，其與
盛開的蓮花相接，取其出淤泥而不染
之意，象徵悟證境界，中央的圓圈符
號則為法輪，轉動法輪即象徵佛陀說
法以摧破眾生煩惱之意。佛教徒認為
見佛之足［足庶］而參拜，如同參拜
生身之佛，可滅除無量之業障。

Buddha Footprint

Material: Gray schist
Era: 2nd century CE
Dimensions: 45.7×45.5×8 cm

In the early days of Buddhism in India, before the trend of realistic depictions of the Buddha's image had formed, the footprint of the Buddha (Buddhapada) was often used as a symbol representing the Buddha or as one of the markers at the Buddha's holy presence. These footprints often featured various decorative motifs with special religious symbolism. The swastika, a common auspicious symbol in Buddhism, also symbolizes the purity and sanctity of the Buddha. The three-pronged symbol represents the Three Jewels of Buddhism: the Buddha, the Dharma, and the Sangha. It is intertwined with blooming lotus flowers, symbolizing the attainment of enlightenment while remaining untainted by worldly attachments. The central circular symbol represents the wheel of dharma (dharmachakra), signifying the Buddha's teaching that destroys the afflictions and pain of beings as it turns. Buddhists believe that seeing the Buddha's footprint and worshipping them is like worshipping the Buddha in his holy presence, which can eliminate infinite karmic obstacles.

金剛杵、金剛鈴

材質：黃銅
年代：西元二十世紀
尺寸：9.5×17.5×9.5 公分

金剛杵，又稱降魔杵，原為古印度之武器，其質地堅固，能擊破各種物質，故冠以金剛之名。後成為密宗諸尊之持物或修行者修法時護持內心所用之法器，象徵除去煩惱之菩提心。金剛鈴表示說法之義，是代表智德的法器，其柄亦呈金剛杵形，為用於督勵眾生精進與喚起佛、菩薩之驚覺所振搖之鈴。兩者多成對使用。

Vajra and Bell

Material: Brass
Era: 20th century CE
Dimensions: 9.5×17.5×9.5 cm

The "Vajra," also known as the "Dorje" or "Diamond Scepter," was originally a weapon in ancient India. It is characterized by its sturdy nature, capable of shattering various substances, hence its name "vajra," which means "diamond" or "thunderbolt" in Sanskrit. Later, it became an essential object for the various deities and practitioners in Vajrayana Buddhism to hold or use during their spiritual practices. It symbolizes the enlightened mind that eliminates afflictions and represents the bodhisattva's intention to attain enlightenment for the benefit of all beings. The bell represents the act of teaching or giving teachings. It is a ritual instrument that symbolizes wisdom and virtue. The handle of the bell is also in the shape of a vajra scepter. It is used to inspire sentient beings to diligently practice and enlighten to the awakened nature of the Buddha and Bodhisattvas through its resonating sound. The two implements are used in pairs.

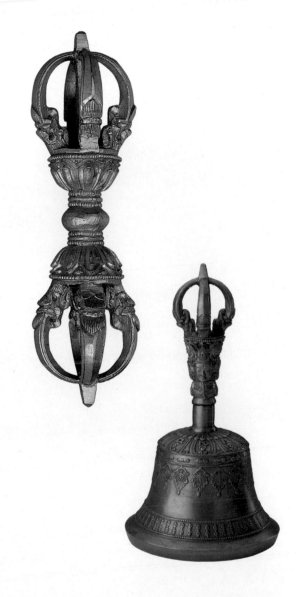

錫克教 Sikhism

透過穿著及配飾與戒律同在
Obedience to the commandments by means of clothing and accessories

錫克教綜合了印度教和伊斯蘭教的傳統，有其獨特的宗教哲學，認為外在的宗教儀式和種姓階級，都與該教所追求的內在靈性成長無關，其終極目標在於與神結合並自「業報」的束縛中解脫。

「錫克」一詞為弟子之意，象徵其信徒為追隨上師言行啟示之門徒，上師是信仰的核心，自那納克上師開始共有十大上師，他們的傳承為錫克教徒立下生活與信仰的根本指南，自古賓上師之後，錫克教聖典《元經》繼承上師之位，該經典被視為諸祖師可見之軀而享有崇高地位。

Sikhism originated in the Punjab region of India and incorporates elements from both Hinduism and Islam. Based on its own unique religious philosophy, Sikhism asserts that external religious rituals and caste divisions are irrelevant to the inner spiritual growth sought by the faith. Its ultimate goal is to attain union with God and liberation from the cycle of karma.

The term "Sikh" translates to "disciple" and symbolizes the followers as disciples who follow the teachings and example of their spiritual guru (teacher). The guru is the central figure in Sikhism. Starting from Guru Nanak, there have been ten Gurus who provide the fundamental guidance for Sikh lifestyle and beliefs.

After Guru Gobind Singh, the Sikh scripture Guru Granth Sahib is regarded as the final Guru. It is revered by Sikhs as the physical embodiment of the enlightened Gurus and holds an unparalleled status in the faith.

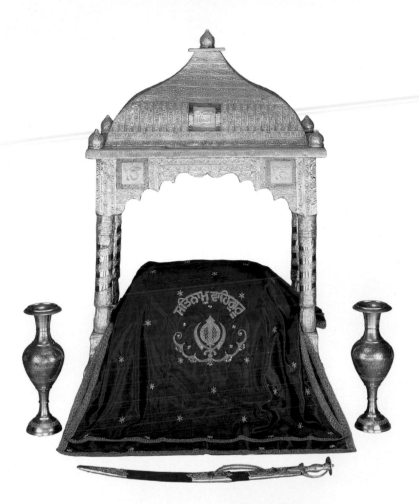

聖典架

材質：木貼錫箔
年代：西元二十世紀
尺寸：**96.8×157.5×59.4** 公分

聖典架是安奉錫克教聖典的寶座，裝飾華
麗，並搭配枕頭、繡金布縵等被視為上師
化身的聖典，如人類上師般受到虔敬的供
奉。此件聖典架採取仿廟宇聖殿的形式，
屋頂的五個尖頂與四方角落的圓柱象徵錫
克教寺廟的屋頂與四方支柱，屋頂四邊與
支柱上方共有8個相同的，金框裝飾的旁
遮普文字，為「唯一真神」之意。

Palki Sahib

Material: Tin foil on wood
Era: 20th century CE
Dimensions: 96.8×157.5×59.4 cm

The "Palki Sahib" is the main structure that houses the Guru
Granth Sahib. The Guru Granth Sahib is placed on a beautifully
decorated throne adorned with pillows, embroidered golden
cloth, and other decorative elements, symbolizing the reverence
and respect given to the scripture, seen as the embodiment
of the spiritual guru. This Palki Sahib is designed in the form of
a replica temple or shrine. The five spires of the roof and the
cylindrical pillars at the four corners symbolize the roofs and
pillars of Sikh temples. On all four sides of the roof and above the
pillars, there are eight identical golden-framed Gurmukhi (Punjabi
letters) representing the phrase "One True God."

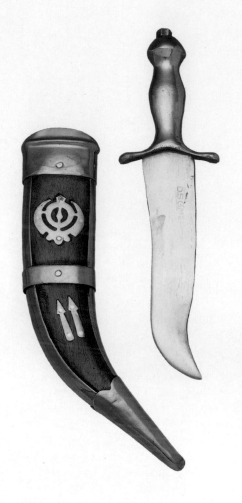

短劍、手環、梳子

材質：金屬、木
年代：西元二十世紀
尺寸：6.5×27.7×2.15 公分（短劍）
　　　7.6×0.79 公分（手環）
　　　9.35×5.55×0.9 公分（梳子）

西元一六九九年古賓‧辛上師創立卡爾
薩教團，要求教徒佩戴五種象徵物：蓄
髮、梳子、短劍、手鐲與短褲。也稱為
「五K」。

奉行「五K」是教徒表現對教團歸順的
外在行為也提醒教團成員要謹記上師言
行。錫克教強調身體的完整性，因此需
蓄髮並保持其清淨；帶梳子，表示注意
儀容與克制心性；穿短褲，象徵道德力
量；戴手鐲，表示對神與上師的忠誠與
教徒的團結；配匕首，為用以維護自由
與自尊的利器。

kirpan (curved sword), kara (bracelet), and kangha (comb)

Material: Metal, wood
Era: 20th century CE
Dimensions:
6.5 ✕ 27.7 ✕ 2.15 cm (curved sword)
7.6 ✕ 0.79 cm (bracelet)
9.35 ✕ 5.55 ✕ 0.9 cm (comb)

In the year 1699, Guru Gobind Singh founded the Khalsa and mandated that the Sikhs should wear five articles of faith: unshorn hair and beard, a comb, a short sword, a bracelet, and shorts. These are collectively known as the 5Ks. Adhering to the "Five Ks" is both an outward expression of allegiance to the Khalsa and a reminder for its members to uphold the teachings and conduct of the Guru. Sikhism emphasizes the integrity of the physical body, hence the requirement to maintain unshorn hair as a symbol of purity. Carrying a comb signifies attention to personal grooming and self-discipline. Wearing shorts represents moral strength. The wearing of bracelets symbolizes loyalty to God, the Guru, and the solidarity with the Sikh community. Carrying a sword serves as a tool for defending freedom and dignity.

道教 Daoism

入世修行是為救難救世
Engaging in worldly practice is to save and help others in need

道教起源於中國，以老子、莊子以及其他道家著作為思想基礎，融合了陰陽與神仙家等諸家學說，形成一以「道」為至高原則的信仰，「道」是萬物運行時所遵循的法則，因此「道」亦指「所行之路」，若遵奉道教所傳授之法，則可順應天道而行，不至逆流受阻。道教重視救難救世，但同樣注重個人的內在實踐，道教相信藉由丹藥、祭儀與存神等各式修練之法，人得以得「道」成仙，擺脫壽命的束縛，而恰是個人超升了，才得以了解並獲得解救他人與社會之理與能。

Taoism originated in China and is based on the teachings of Laozi, Zhuangzi, and other Taoist sages. It integrates various philosophical theories such as Yin-Yang and the School of Celestial Masters (神仙家), forming a belief system centered around the supreme principle of the "Tao" (the "Way" or the "Path"). The Tao is the fundamental principle that governs the truth of all things. By following the Tao, deities and all things are brought into existence. Therefore, in Taoism, the "Tao" also refers to the "Way" one should follow. By adhering to the teachings of Taoism, one can align with the natural order of the Tao and avoid going "against the flow".

Like many other religions, Taoism places importance on saving and benefiting mankind. However, Taoism also emphasizes individual spiritual practice. Taoism believes that through various forms of cultivation such as alchemy, rituals, and spiritual preservation, individuals can attain the "Tao" and achieve immortality. Furthermore, by transcending the cycle and limitations of life and death; it is through personal spiritual transcendence that one can comprehend and attain the principles and power to save others and contribute to society.

諸神圖

材質：紙
年代：待考
尺寸：67.8 ×148.5公分

道教流傳於中國西南地區所設的壇場，多在正中高懸一巨幅神圖，稱為「總真圖」，通常用於儀式法場佈置，是道壇至為重要的法物。諸神圖掛軸採由上至下排列方式，三清位居最上端，是道教天地運化的象徵，也是道教最高精神「道」的神格化展現，其下以中尊為主，依次為東王公、西王母、斗姥等，左右分列相關神祇，構成層級分明的神譜圖像。

Illustration of the Daoist Pantheon (Zhu Shen Tu)

Material: Paper
Era: To be determined
Dimensions: 67.8 ×148.5 cm

Mainly practiced in the southwestern region of China, it iscommon to find a large-scale diagram of deities called the "Zong Zhen Tu " (總真圖) prominently displayed at the center of Taoist altars and temples. They are considered a crucial ritual artifact in Daoist practice. The arrangement of the deities in the Illustration of the Daoist Pantheon (Zhu Shen Tu) hanging scroll follows a top-to-bottom order. At the topmost position are the Three Pure Ones (San Qing), symbolizing the celestial manifestation of the Taoist cosmological principles and representing the highest spiritual essence of Taoism; the "Way" itself. Below them, the central figure takes prominence, followed by the Dong Wang Gong (Eastern Prince), Xi Wang Mu (Queen Mother of the West), and Dou Lao (Mother of the Great Wagon) who are arranged in a hierarchical manner on both sides, This composition creates a clear depiction of the divine hierarchy and showcases the relationship between different gods within the Taoist pantheon.

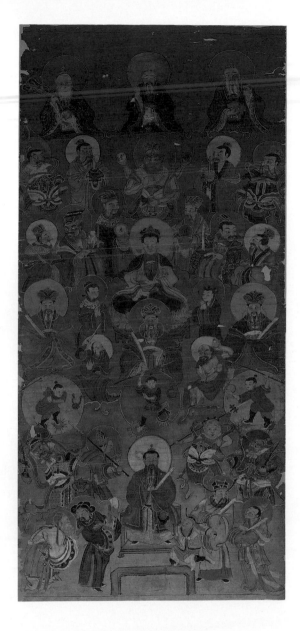

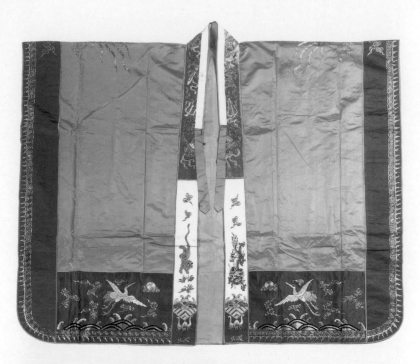

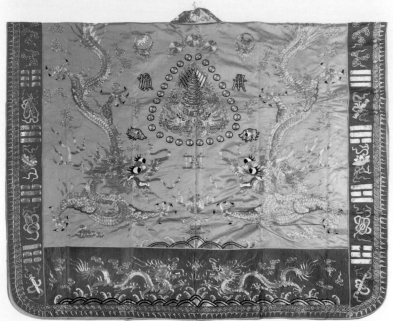

高功絳衣

材質：布
年代：西元二十世紀
尺寸：217×120×35公分

高階的道士「高功」所著之法服稱為「絳衣」，多為黃或紅色，兩袖與衣身合為四方型，以象天地四方，其上刺繡圖像最為繁複尊隆。此套絳衣以金龍圖樣為主，正中繡有四爪金龍搶珠一對，四圍則飾以八朵祥雲，以象雲中龍；其下以金線及藍、白線繩出波浪紋。雙緣黑底上繡金龍一對，飾以雲紋。龍為至尊之象，高功以此展現尊貴的身分。

Gaogong Ceremonial Robes

Material: Fabric
Era: 20th century CE
Dimensions: 217×120×35 cm

The ceremonial robes worn by senior Taoist priests, known as "Jiang Yi" (絳衣), are often yellow or red in color. The sleeves and body of the robe are combined into a square shape, symbolizing the four cardinal directions of the universe. The embroidered designs on these robes are intricate and elaborate, showcasing the highest level of craftsmanship and reverence. This set of Jiang Yi features a prominent design of a golden dragon. The center features an embroidered pair of four-clawed dragons fiercely guarding a precious pearl. Surrounding the dragons are eight auspicious clouds, symbolizing dragons in the clouds. Below the dragon motif, there are wavy patterns created using gold threads, as well as blue and white threads. Set against a black background, a pair of embroidered golden dragons are adorned with cloud patterns. The dragon is a symbol of supreme authority. Through the dragon motif, the Gaogong Taoist priest showcases their venerated status.

七星劍

材質：金屬
年代：待考
尺寸：5×46.2×2公分

七星劍又稱寶劍、法劍，為斬妖驅邪的法器。與一般刀劍相異之處，在其劍身嵌有七顆鈕釘以固夾鋼，以象徵北斗七星，藉其威力驅除邪精，為傳說中道教祖師張天師所用法器之一；有時劍身也可飾以符文，增強其靈力。道士以之為護身之用，在壇上用以召四靈，民間常高懸作為辟邪的法器。

Qixing Sword (Seven-Star Sword)

Material: Metal
Era: To be determined
Dimensions: 5*46.2*2 cm

The Qixing Sword, also known as the Treasure Sword or Magic Sword, is a sacred weapon used for slaying demons and warding off evil spirits. The Qixing Sword differs from conventional swords in that it has seven rivets embedded in its blade, symbolizing the seven stars of the Big Dipper. This design is believed to possess the power to repel evil spirits and demons. It is said to be one of the legendary Celestial Master Zhang's magical weapons. Sometimes, the blade of the sword can also be adorned with inscriptions or symbols to enhance its spiritual potency. Taoist priests use it for protection, on the altar to summon the Four Spirits, and it is often hung high as a magic weapon to ward off evil spirits in the community.

神道教 Shinto

與八百萬神共處的崇神之道
The Way of Living with Eight Million Gods

神道是日本最古老的宗教。這個名稱的意思是「諸神的道路」，它是一種自然宗教，包括海、山、動物、植物，甚至駭人聽聞、可怕或神秘的事物，都可以稱之為神。

神道教並不強調對歷史人物的偶像崇拜、神聖經文或系統化教義。它常常被視為人們抱持的共同價值觀和生活方式，而神話和宗教儀式才是維繫信徒的關鍵。神道教最重要的觀念是要「潔淨」，由於人類本性善良，只要將污穢去掉，與生俱來的善良便會顯露出來。因此，神道教的儀式崇尚回歸純淨自然。

Shintoism is the oldest religion in Japan. The meaning of "Shinto" is "The Path of the Gods." It is a form of nature religion that encompasses the sea, mountains, animals, plants, and even awe-inspiring, terrifying, or mysterious things, all of which can be referred to as gods.

Shintoism does not emphasize the idol worship of historical figures, sacred scriptures, or systematic doctrines. Rather, Shintoism is often regarded as a shared set of values and a way of life for its adherents. Furthermore, mythology and religious rituals play a crucial role in maintaining the connection and devotion of its believers. The most important concept of Shintoism is to be "clean". Since human beings are "good" by nature, their innate goodness will be revealed once the "filth" is removed. Therefore, the Shinto rituals are based on a return to the purity of nature.

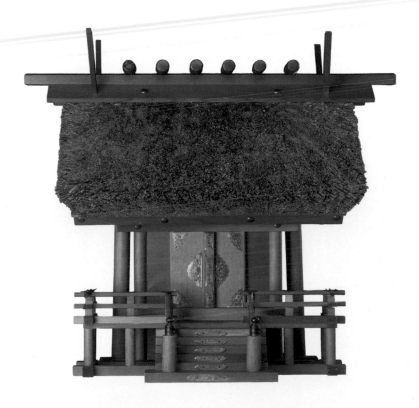

神棚

材質：木

年代：西元二十世紀

尺寸：48.8 ✕42 ✕30.8 公分

神棚是家庭供奉神明的祭壇，神棚就像是一個小型的神社，奉祀當地的守護神或是伊勢神宮的神，在每天的早晨和晚上奉獻鹽巴、米和水等。

Kamidana

Material: Wood

Era: 20th century CE

Dimensions: 48.8 ✕42 ✕30.8 cm

A "kamidana" is a household altar where deities are enshrined. It is like a miniature Shinto shrine and typically worships the local guardian deity or the gods of Ise Grand Shrine. Every morning and evening, offerings such as salt, rice, and water are dedicated to the deities.

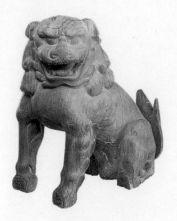
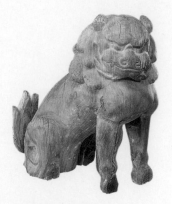

獅子·狛犬

材質：木
年代：西元1185-1333年
尺寸：29.5 ×48.5 ×43公分；26.1 ×49 ×44.8公分

這對藏品也稱為「高麗獅子狗」。其中張口的是獅子，閉口的是狛犬。各自立於神社的拜殿前，守護神社，防止危險或邪靈的入侵。

Komainu

Material: Wood
Era: 1185 - 1333 CE
Dimensions: 29.5 ×48.5 ×43 cm; 26.1 ×49 ×44.8 cm

This paired animal is also known as the "Goryeo Lion-Dog". The creature with the open mouth is the lion, and the creature with the closed mouth is the dog. They stand in front of the worship altars at Shinto shrines, guarding and preventing the intrusion of danger or evil spirits.

山神像

材質：木雕上彩
年代：西元1338-1476年
尺寸：8.8 ×37.3 公分

在日本，幾乎每座山都有統稱為「山王」，受到當地民眾崇拜的神祇；這一對藏品是日本比叡山的山王，左邊的是大行事神，右邊的是山末神。

Sanno Sculpture

Material: Color on wood sculpture
Era: 1338-1476 CE
Dimensions: 8.8 ×37.3 cm

In Japan, almost every mountain has a deity revered by the local people, collectively known as "Sanno". This pair of artifacts represents the Sanno of Mount Hiei in Japan; the deity on the left is the Daigyouji-no-kami, associated with major events and ceremonies, to the right is Yamasueno-oonushino-kami.

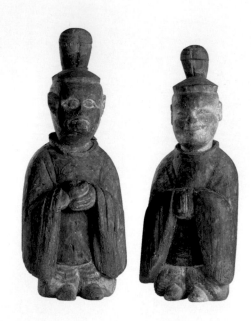

注連繩

材質：稻草
年代：西元二十世紀
尺寸：**97** ╳**18** ╳**5** 公分

注連繩是標示出神聖區域的草繩，大
多是懸掛在神社入口處的鳥居或神棚
前面，而注連繩上通常吊掛著紙片，
作為供奉給神祇的供品。

Shimenawa

Material: Straw
Era: 20th century CE
Dimensions: 97 x 18 x 5 cm

The "Shimenawa" is a rope that signifies
a sacred area. It is often hung in front of
the torii gate or kamidana (altar) at the
entrance of Shinto shrines. The Shimenawa
usually has paper strips attached to it as
offerings to the deities.

民間信仰 Religious Life of the Taiwanese

既祭上天亦祭祖的常民信仰
Folk beliefs that includes worshiping both deities and ancestors

此臺灣民間信仰係指漢民族信仰，其根基於漢民族悠久的歷史，其教義、儀式及組織都與世俗的社會生活合而為一。因此，臺灣人的信仰及儀式行為表現在許多不同的生活面向上，如生命禮俗、時空間觀念、符咒法事以及卜卦算命等。

臺灣民間信仰中沒有統一的教義和經典，以「敬天」、「崇祖」等兩大面向為主要信念，敬天就是敬畏自然、順天行事；崇祖就是飲水思源、慎終追遠。透過對於祖先與神明的祭祀，期望能獲得來自上天的助力外，也會定期性的舉辦盛大的地域性宗教祭典。

Taiwanese folk beliefs mainly refers to the Han Chinese folk belief system, which is rooted in the long history of the Han Chinese. Its doctrines, rituals, and organizations are well integrated with secular lifestyles. Therefore, the beliefs and ritual practices of the Taiwanese people are manifested in various aspects of life, such as life-and-death rituals, concepts of time and space, the use of charms and spells, as well as divination and fortune-telling through methods like divination charts.

In Taiwanese folk belief, there is no consistent or systematic doctrine or scripture. The main beliefs revolve around two aspects: "Jing Tian (敬天)" (revering heaven) and "Chong Zu (崇祖)" (venerating ancestors). Revering heaven involves showing awe and respect towards nature and acting in accordance with its principles. Venerating ancestors emphasizes the importance of recognizing one's roots and showing reverence towards one's ancestors throughout the generations. In addition, there are regular grand religious ceremonies held, and these events serve as key occasions for religious gatherings and rituals.

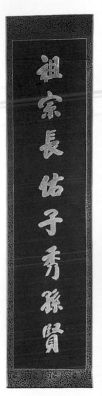

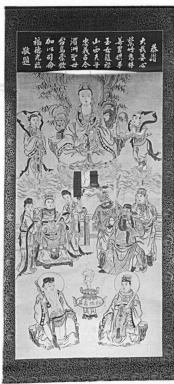

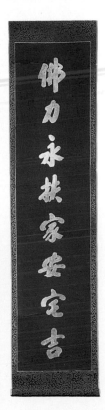

觀音媽聯

材質：紙
年代：西元二十世紀
尺寸：149.5×66.5公分

以觀音為主神的數位神祇同列於掛
軸，民間習稱「觀音媽聯」，普遍懸
掛於民宅公廳之中，作為家宅或祠堂
的祭祀對象。此中堂掛軸區分為三
層，上層為觀音與善財龍女，中層為
關帝與天上聖母，下層為司命灶君與
福德正神。再配上一副對聯，是較簡
單的組合形式。上書「佛力永扶家安
宅吉，祖宗長佑子秀孫賢」。

Guanyin Malian

Material: Paper
Era: 20th century CE
Dimensions: 149.5×66.5 cm

Several deities are featured, with Guanyin, the goddess of mercy, usually
as the central deity. This is commonly referred to as "Guanyin Malian"
in Taiwanese folk belief. They are commonly displayed in households
and public halls as objects of worship for homes or ancestral altars. The
hanging scroll in the central hall is divided into three tiers. The upper tier
features Guanyin and the Dragon Maiden of Good Fortune (善財龍女).
The middle tier includes Guan Yu and the goddess Mazu. The lower tier
consists of the Kitchen God and the Fude Zhengshen (Earth God). This is
often added with a pair of couplets to form a relatively simple combination.
The couplet is inscribed as "with the eternal support of Buddha's power,
the home is blessed; while the ancestors ensure the excellence and virtue
of future generations" (佛力永扶家安宅吉，祖宗長佑子秀孫賢).

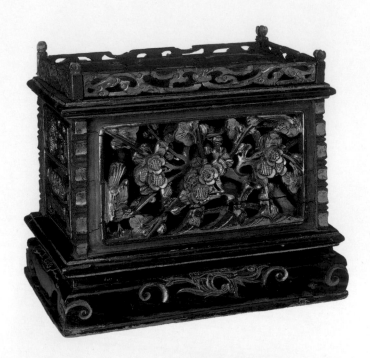

薦盒

材質：木雕上彩
年代：待考
尺寸：32 ╳ 28 ╳ 20.3公分

薦盒為祭祀用具之一，上置酒杯以盛酒供神的水酒檯架。常放置於供桌中央香爐之前，其上方平台用來放置酒杯（通常為三只）以作為獻爵（獻酒）之用，通常在祭祀過程中分三次添酒，稱為一巡、二巡、三巡，一般宮廟、祠堂、家庭均有使用。薦盒的材質多以木質或錫製，其形制與刻工裝飾多元豐富，常以吉祥圖案為主。常見的薦盒多作小型單層神案造型，雖然造型不同，而其供神的功能則是一致的。

Offering Box

Material: Color on wood sculpture
Era: To be determined
Dimensions: 32 ╳ 28 ╳ 20.3 cm

The "Offering Box" (薦盒) is one of the ritual items used in worship. It is a tray or stand that holds wine cups for offering wine to the deities. The Offering Box is commonly placed in front of the central incense burner on the altar table. The platform on top is used to hold wine cups, usually three of them, for the wine offering ritual. During the worship ceremony, wine is added three times, known as the first round (一巡), second round(二巡), and third round(三巡). This practice is observed in temples, ancestral halls, and households alike. The Offering Box is often made of wood or tin, and its design and decorative carving can vary greatly. It is commonly adorned with auspicious motifs and patterns, featuring a diverse range of artistic styles. In most cases, Offering Boxes take the form of a small, single-layer bodies. While the specific designs may vary, the purpose of offering to the deities remains consistent across different styles and forms.

龍燭燭台

材質：複合材料
年代：待考
尺寸：16 ×48 ×10公分

燭台是神案供桌上的祭祀用具之一，用
來固定蠟燭，置於神案兩側以祭獻神
明。傳統祭祀的用品，除了金紙與香
外，蠟燭亦是不可或缺的一項物品，蠟
燭點火，除有照明功用外，亦象徵神光
普照，光明常在之意。燭台形制多元豐
富，為表虔誠敬神之意，裝飾亦以吉祥
圖案為主，此龍燭台身作龍柱形，上有
蟠龍、壽仙、麻姑與八仙等雕飾，底座
為錫製蓮花六角台。

Dragon Candlestick

Materials: Composite
Era: To be determined
Dimensions: 16 ×48 ×10 cm

The candlestick is one of the ritual utensils
found on the shrine altar. It is used to hold
and secure candles and is typically placed
on both sides of the shrine altar as an
offering to the deities. In traditional rituals,
in addition to joss paper and incense,
candles are an essential item. Lighting
candles serves not only the purpose of
illumination but also symbolizes the divine
light shining and the presence of eternal
illumination. Candlesticks come in many
forms and designs, are often adorned with
auspicious motifs, reflecting the devoutness
and reverence to deities. In the case of the
dragon candlestick, it takes the shape of a
dragon pillar, featuring carvings of coiling
dragons, immortals, Magu, and the Eight
Immortals. The base is a hexagonal tin lotus
flower platform.

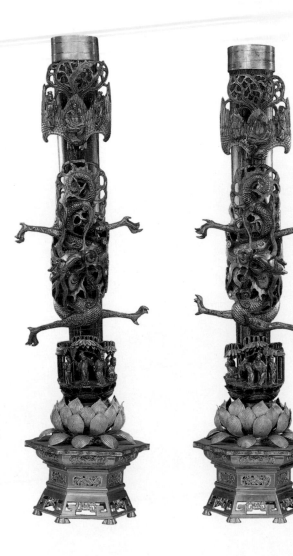

世界宗教建築模型展示區
The Greatest Sacred Buildings

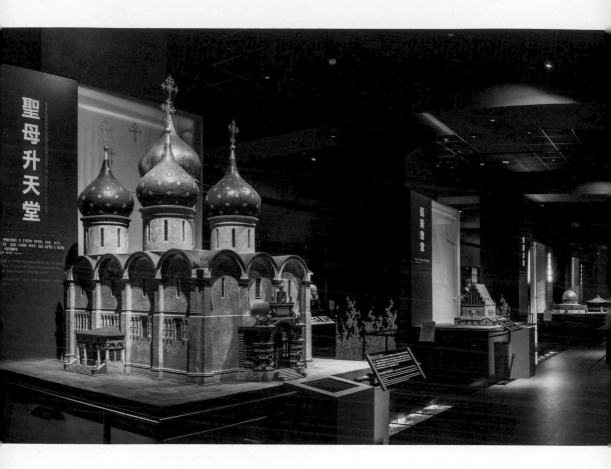

宗教建築無疑是各地代表性的文化景點，建築美學，工藝技法，時代與地域文化的體現，在在引人入勝。它們是凝聚跨世代跨地域人們的場域，更是人真心以美來顯耀善的價值的聖殿。在這個位於展廳中央的區域，是二○○三年時任館長的漢寶德老師與雕塑家林健成先生合作，挑選了具有歷史價值和建築特色的宗教建築，以一比三十或一比五十的比例製作的高精度建築模型。藉由這些精巧的大比例模型，我們得以離開仰望讚嘆的視角，看到建築佈局和細節。巧妙的是，模型內部的微縮攝影機將建築內部影像投射在銀幕上，模擬人們進入建築內部的視角和感官，讓觀眾彷彿身臨其境，走進神殿！

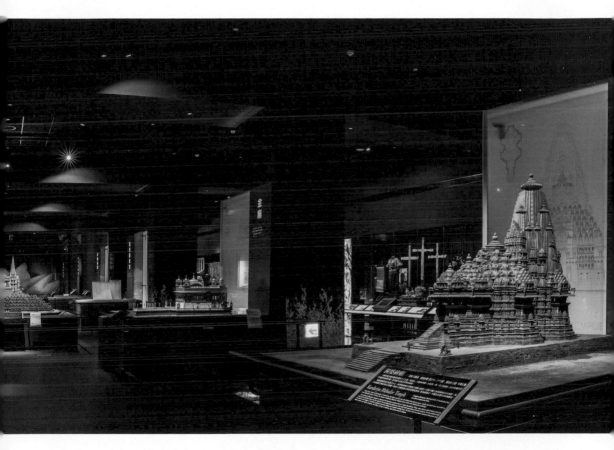

Religious architecture is undoubtedly a symbolic cultural attraction of each region, and the aesthetics of architecture, craftsmanship, and the manifestation of the times and regional culture are all fascinating. It is a place that unites people across generations and regions, and a sanctuary where people genuinely demonstrate the value of goodness through beauty. In this central area of the exhibition hall, Mr. Han Baode, the ex-director of the museum, and sculptor Mr. Lin Jiancheng collaborated in 2003 to select religious buildings with historical value and architectural characteristics and to create high-precision architectural models at a scale of one to thirty or one to fifty. Through these exquisite large-scale models, we are able to see the layout and details of the buildings out of the perspective of admiration. Besides, the mini cameras inside the models project the effects of the building's interior onto the screen, simulating the perspective and senses of people entering the building, allowing the audience to walk into these sacred structures as if they were really there!

圓頂清真寺

Dome of the Rock

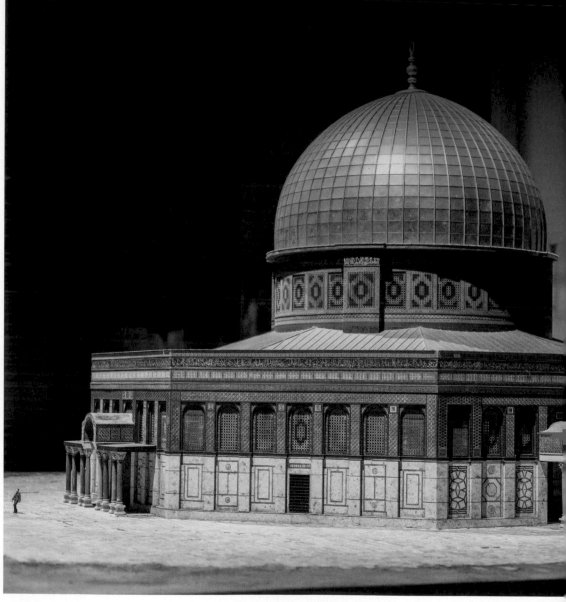

宗教：伊斯蘭教
建造時期：西元七世紀
建造地：耶路撒冷
模型比例：1：50

圓頂清真寺位於耶路撒冷舊城內，亦有「薩赫萊清真寺」或「聖石圓頂」之稱。金色圓頂上佇立著新月形的標誌，建築外觀呈八角形，大理石牆壁上鑲嵌著彩色馬賽克磁磚與玻璃，上方以古蘭經文裝飾，內部圓柱與拱形門羅列，環繞著中央的白色聖石。寺內的白色岩丘是先知穆罕默德夜行登霄（al-Isra wa al-Miraj）時所踏的岩石。

Religion: Islam
Period of construction: 7th century C.E.
Location: Jerusalem
Model Scale: 1:50

Located in the Old City of Jerusalem, the Dome of the Rock is also known as Qubbat aṣ-Ṣakhra. The golden dome, with its crescent-shaped finial, is an octagonal building with marble walls inlaid with colorful mosaic tiles and stained glass, decorated with Qur'anic verses. Its interior columns and arched doors are surrounding a white stone in the center of the structure. It is the rock on which Prophet Muhammad ascended to heavens in his night journey (al-Isra wa al-Miraj).

路思義教堂
Luce Chapel

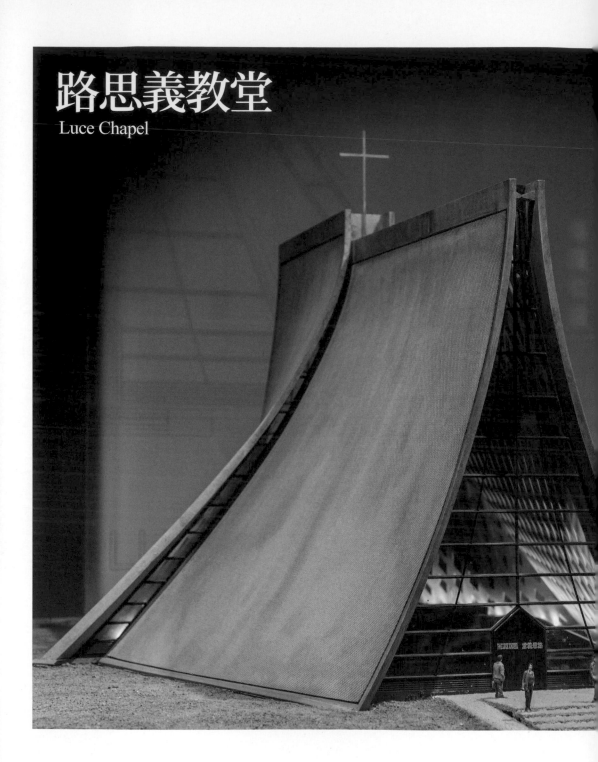

宗教：基督教
建造時期：西元二十世紀
建造地：台灣台中
模型比例：1：30

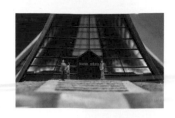

路思義教堂為紀念路思義牧師
所建，於西元一九六三年完成。
教堂位於東海大學校園中心，因
建築結構與規劃的創新巧思，不
但成為學校信仰中心，亦是聞名
中外的建築傑作。教堂外牆由四
片分離的雙曲面組成，屋面、牆
體與樑柱合一，建築結構輕巧流
暢。內部空間簡樸，分為講壇與
席座，講壇上方的金黃色十字
架，與從天窗透入的自然光線，
相互輝映，搭配向上延伸的格子
樑與玻璃格窗，呈現神聖之感。

Religion: Christianity
Period of Construction: 20th century C.E.
Location: Taichung, Taiwan
Model Scale: 1:30

Luce Chapel was built as a memorial to
an American missionary Dr. Henry W.
Luce (1847-1941). It is located in the
campus center of Tunghai University.
The church is not only the center of the
university's faith activities, but also a well-
known architectural masterpiece due to its
innovative structure and planning.
The exterior walls of the church are
composed by four separate hyperbolic
surfaces, and the roof, walls and beams are
united, making the structure of the building
light and smooth. The interior space holds
great simplicity, divided into an altar and
seats. The golden cross above the altar
and the natural lights reflect on each other,
and the lattice beams and glass windows
extending upward, bringing great sense of
sacredness.

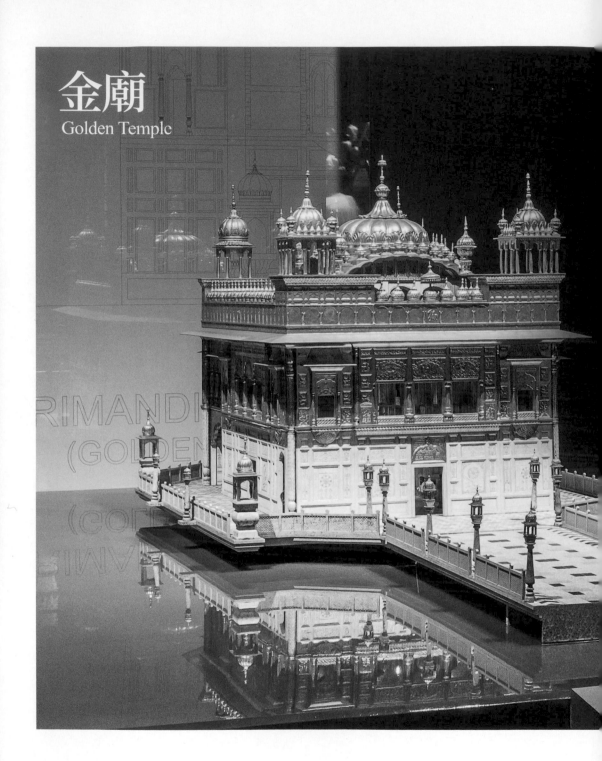

金廟
Golden Temple

宗教：錫克教
建造時期：西元十六至十七世紀
建造地：印度阿姆利則
模型比例：1：30

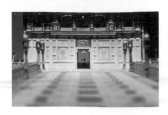

金廟是錫克教最重要的政治及宗
教中心，由阿爾將上師始建，完
成於西元一六〇一年。十九世紀
初，藍吉特‧辛格大王以大理石
與黃金修建，圓頂與牆面綴滿黃
金，因而得名。
旁遮普語稱金廟為「神的住所」。
廟內有主殿、誦經室、休息室等
空間，拱門與牆面上飾有傳統雕
刻花紋及宗教的讚美詩句。金廟
座落於有「不朽之湖」之稱的阿
姆利則湖中，有「堤道」與大理
石建造的環湖步道相連。

Religion: Sikhism
Period of construction:
16th to 17th century C.E.
Location: Amritsar, India
Model Scale: 1:30

The Golden Temple, the most important
political and religious center of Sikhism,
was built by Guru Arjan and completed
in 1601. It was rebuilt in the early 19th
century by Maharaja Ranjit Singh with
marble and gold, and the dome and walls
are covered with gold and led to the name
Golden Temple.
In Punjabi, the Golden Temple is called the
"abode of the gods". The temple has a main
hall and rooms for worshipping and resting,
and the arches and walls are decorated with
traditional carvings and religious texts. The
Golden Temple is in the center of Amritsar
Lake, which is known as the "Lake of
Immortality", and a causeway connects the
temple with the marble walkways surround
the lake.

伊勢神宮
Ise Grand Shrine

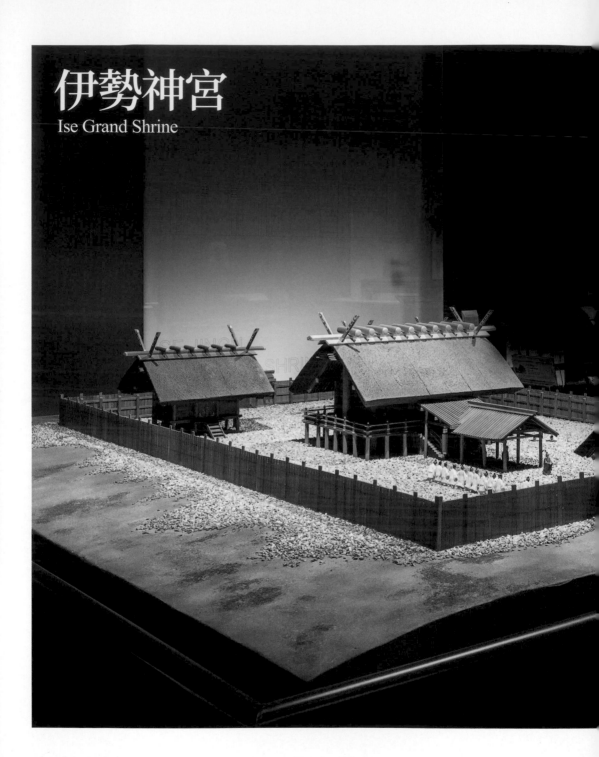

宗教：神道教
建造時期：西元二世紀
建造地：日本三重縣
模型比例：1：30

伊勢神宮位於伊勢灣西南的廣
大森林之中，由百餘座神社所組
成，並以供奉天照大神的皇大神
宮(內宮)為首，其神社數量之多
與神祇之龐雜，象徵「神道」兩
千多年來漫長歷史累積的成果。
伊勢神宮的建築原形，由收藏神
寶或儲藏神田米穀的倉庫發展而
來。以樸實的原木築成，地板多
架空，四周以玉垣（木柵欄）作
為分隔。屋頂呈山形，其上舖葺
草（茅草），搭配屋頂上耀眼的
金黃色裝飾，神聖潔淨。

Religion: Shinto
Period of Construction:
2th century C.E.
Location: Mie Prefecture, Japan
Model Scale: 1:30

Ise Jingu is located in the vast forest
southwest of Ise Bay and consists of
more than a hundred shrines, led by the
Imperial Grand Shrine（Naiku）, which
is dedicated to Amaterasu Omikami. The
original form of Ise Jingu was developed
from a storehouse where sacred treasures
were kept. The building is made of rustic
logs, with a hollow floor and surrounded by
a wooden fence. The roof is shaped like a
mountain and covered with thatched grass,
and there are dazzling golden decorations
on the roof to show sacredness and beauty.

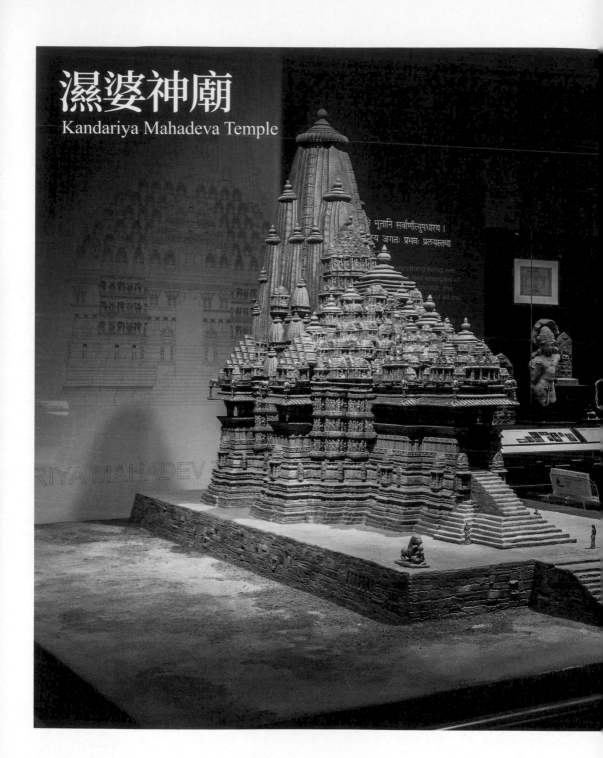

濕婆神廟
Kandariya Mahadeva Temple

宗教：印度教

建造時期：西元十至十一世紀

建造地：印度卡傑拉霍

模型比例：1：30

卡傑拉霍的廟宇是印度中北部昌
德拉土朝時期的重要建設，全盛
時期曾有廟宇八十五座，現僅存
二十餘座神廟，分為東、南、西
三個廟群。其中西廟群的坎德里
雅濕婆神廟，即為當時的代表建
築。坎德里雅濕婆神廟是一座建
造於基座平台上的層疊式殿堂，
外牆上刻滿了栩栩如生的神獸、
飛天與細膩生動的愛侶交媾的情
慾雕像。基座牆面的線條與花草
紋樣極為繁複，穿插著蓮花形、
半圓形及壺形的裝飾雕刻。

Religion: Hinduism
Period of Construction:
10th to 11th century C.E.
Location: Khajuraho, India
Model Scale: 1:30

The temples of Khajuraho were important
constructions during the Chandela dynasty
in north central India, and there were 85
temples in their heyday. Among them, the
Kandariya Mahadeva Temple in the west
temple complex is a great representative
of buildings of that time. The Kandria
Mahadeva Temple was built on a pedestal
platform with multiple levels, the outer
walls of which are covered with carvings
of beasts, flying celestial beings, and
delicate and vivid statues of lovers having
intercourse. The walls of the pedestal are
decorated with intricate lines and floral
motifs, interspersed with lotus, semicircles,
and jug-shaped decorative carvings.

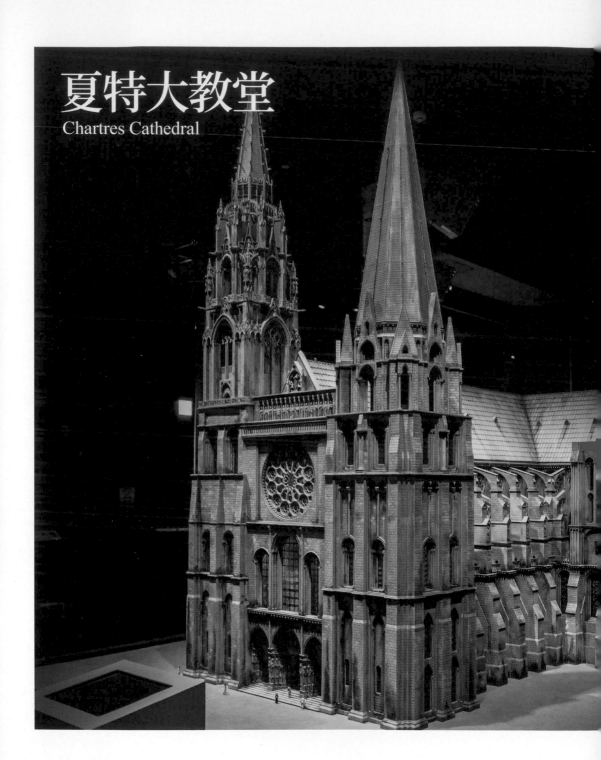

夏特大教堂
Chartres Cathedral

宗教：天主教
建造時期：西元十二至十三世紀
建造地：法國夏特
模型比例：1：50

夏特大教堂為法國哥德式建築的典範。大教堂的內部由石柱與拱頂組成，外部則設計「飛扶壁」用以承重，使大教堂顯得優雅輕巧，而整體建築的空曠高遠，更傳遞出直達天國的莊嚴氣勢。夏特大教堂為傳統的拉丁十字形，中堂地板上有祈禱用的迷宮圖案。大教堂以聖經故事為題材的浮雕與大小雕像遍佈教堂各處，令人讚嘆；瑰麗奇巧的彩色玻璃，以圖畫傳述宗教故事，呈現出特有的神秘美感。

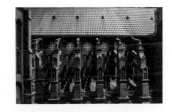

Religion: Christianity
Period of Construction:
12th to 13th century C.E.
Location: Chartres, France
Model Scale: 1:50

Chartres Cathedral is an outstanding example of French Gothic architecture. The interior of the cathedral is composed of stone columns and vaults, while the exterior is designed with flying buttresses for weight-bearing, making the cathedral looks elegant. The cathedral is in the shape of a traditional Latin cross, and the floor of the nave is decorated with a labyrinth for prayers. The cathedral's biblical reliefs and statues are scattered throughout the church, and the magnificent stained glass, with its pictorial narrative of religious stories, presents a unique mystical beauty.

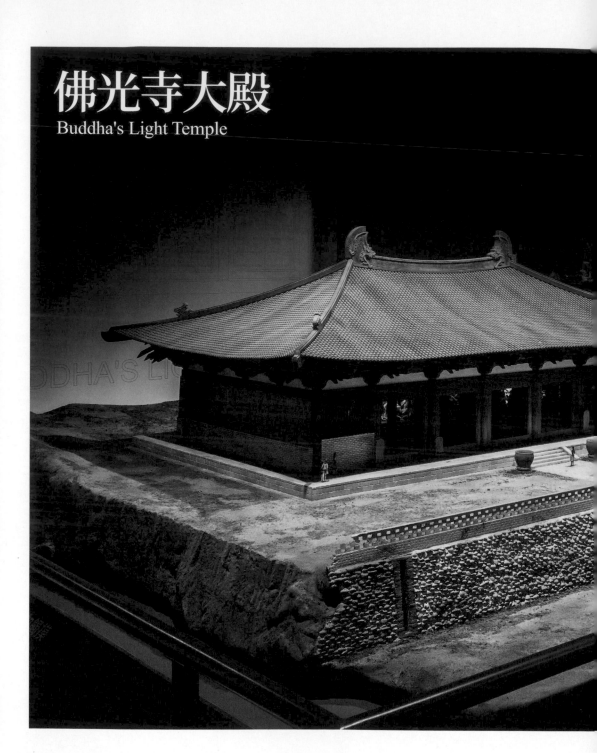

佛光寺大殿
Buddha's Light Temple

宗教：中國佛教
建造時期：西元九世紀
建造地：中國大陸山西
模型比例：1：30

佛光寺位於山西省五台縣，分
為三層院落，現存有殿、堂、
樓、閣等一百二十餘間。其正殿
又稱為東大殿，斗拱雄大，樑架
錯落深遠，是現存唐代木架構佛
寺建築中最典型的代表建築。東
大殿內牆繪有羅漢與佛經壁畫，
兩側與後部，羅列二百餘座明代
的羅漢塑像；佛壇上供有多尊高
大的唐代彩塑佛像。佛光寺大殿
保存了唐代建築、雕塑、繪畫等
精華，具有高度的歷史和藝術價
值。

Religion: Buddhism
Period of Construction: 9th Century C.E.
Location: Shanxi Province, China
Model Scale: 1:30

Located in Wutai County, Shanxi Province,
Foguang Temple is a three-part compound
with more than 120 halls, chambers,
buildings and pavilions. The main hall, also
known as the Eastern Hall, with its majestic
arch and staggered beams, is the most
typical existing representative building of
Tang Dynasty wooden-frame Buddhist
temple architecture. The inner walls of the
East Hall are painted with wall paintings
of Luohan and Buddhist scriptures, and
more than 200 statues of arhat from the
Ming dynasty are listed on both sides and
at the rear; the Buddha altar is decorated
with many tall statues of the Buddha from
the Tang dynasty. The hall has preserved
the essence of architecture, sculpture and
painting of the Tang Dynasty and has high
historical and artistic value.

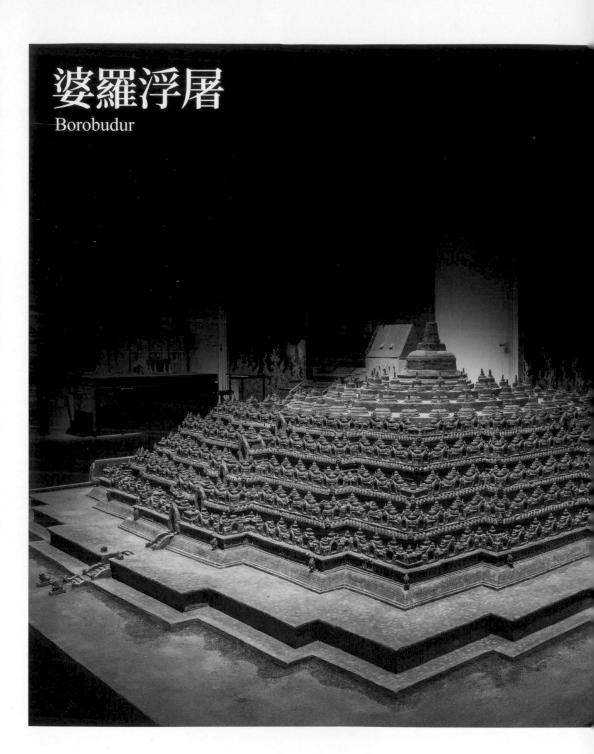

婆羅浮屠
Borobudur

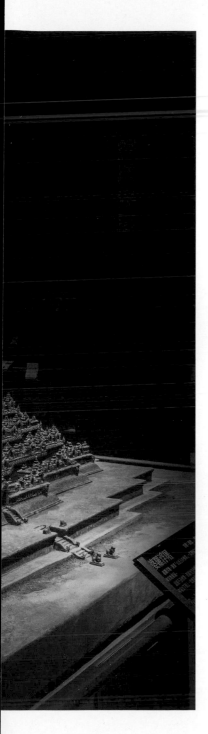

宗教：南傳佛教
建造時期：西元九世紀
建造地：印尼爪哇
模型比例：1：50

婆羅浮屠，意為「山丘上的佛塔」。原本深埋於火山泥中，直至西元十九世紀，因為地面的佛像微露才挖掘出地下的宏偉建築。婆羅浮屠為一外方內圓的石造建築，自下而上，漸次升高，象徵修行成佛的境界，自上方鳥瞰猶如立體曼陀羅，深具宗教意涵。波羅浮屠的雕刻以佛像雕塑與浮雕為主，佛像放置在各層平台的佛龕與頂部的舍利塔中，數量眾多的壁面浮雕，多以佛陀生平與佛經故事作為敘事題材。

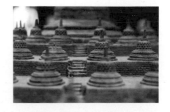

Religion: Buddhism
Period of Construction:
9th Century C.E.
Location: Java, Indonesia
Model Scale: 1:50

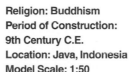

The name Borobudur literally means "stupas on a hill". Originally buried deep in volcanic dust, the magnificent structure was excavated in the 19th century when the Buddha statue on the ground was slightly exposed. Borobudur is a stone structure with a square exterior and a round interior, rising gradually from the bottom to the top, symbolizing the realm of Buddhahood, and looking from above like a standing mandala, which has a deep religious connotation. The sculptures of Borobudur are mainly Buddha sculptures and reliefs, and the Buddha statues are placed in the niche on each platform and in the stupa at the top, and the numerous wall reliefs are mostly based on the life of Buddha and the stories of Buddhist scriptures.

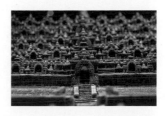

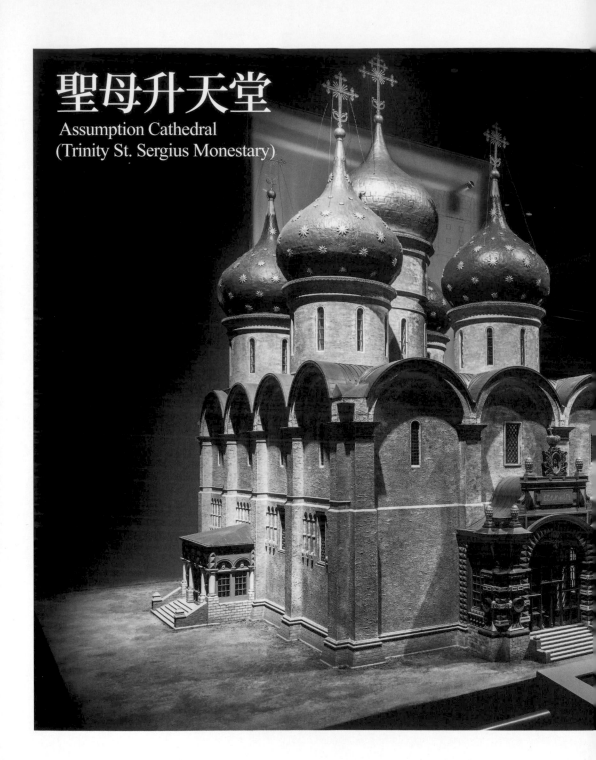

聖母升天堂

Assumption Cathedral
(Trinity St. Sergius Monestary)

宗教：東正教
建造時期：西元十六世紀
建造地：俄羅斯札格爾斯克
模型比例：1：30

聖三一修道院由俄羅斯聖者塞爾吉斯創立。由於教會權力的掌控與歷經多次戰爭，聖三一修道院遂由教堂群與軍事堡壘共同組成，並收藏著許多古籍史料與藝術品。聖母升天堂即為其中規模最大的主要建築。聖母升天堂由沙皇伊凡四世下令建造，仿自克里姆林宮五圓頂的聖母升天堂，牆壁以純白石灰石砌成，屋頂則是揉雜拜占庭風格的藍底金星蔥頂，形成特殊的俄羅斯教堂建築，內部以聖像畫作為裝飾。

Religion: Christianity
Period of Construction:
15th to 18th century C.E.
Location: Zagorsk, Russia
Model Scale: 1:30

Trinity St. Sergius Monastery is located in the small town of Sergiev Posad, on the outskirts of Moscow. The Monastery was founded by the Russian saint Sergius. Due to the control of the Church and many wars, Holy Trinity Monastery consists of a church complex and a military fortress with a collection of ancient historical materials and artifacts. The Assumption of the Blessed Virgin Mary is the largest and most important of these buildings.

The walls are made of pure white limestone, and the roof is a blue and gold star roof in Byzantine style and decorated with icons inside the building. This monastery is an outstanding example of Russian church architecture.

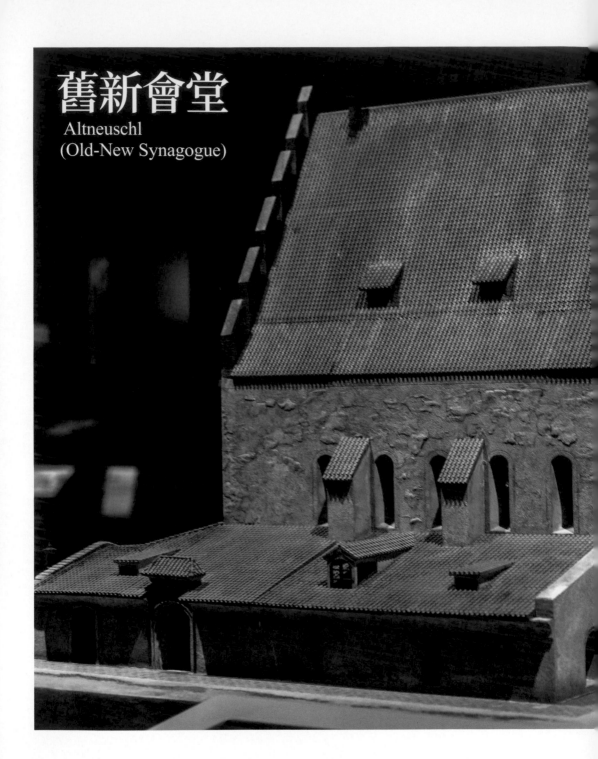

舊新會堂
Altneuschl
(Old-New Synagogue)

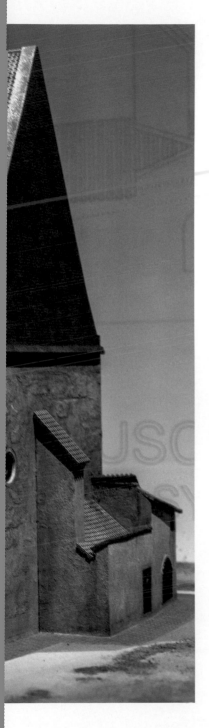

宗教：猶太教
建造時期：西元十三世紀
建造地：捷克布拉格
模型比例：1：30

舊新會堂是歐洲現存最古老的猶太會堂，會堂大廳是唯一從中古時代留存至今的歷史建築，古老而深具宗教意義。猶太人在耶路撒冷聖殿被毀後，將許多傳統儀式留存在會堂禮拜中，成為猶太教徒的重心。舊新會堂是灰色石造雙層式建築，顯現中古時期建築的藝術風格。內部以放置猶太律法的「約櫃」為中心，象徵聖殿的聖所；前方是誦經壇，高掛著一面大衛之星旗幟，四周圍繞著教室及浸禮堂等小房間。

Religion: Judaism
Period of Construction:
13th century C.E.
Location: Prague, Czech Republic
Model Scale: 1:30

Trinity St. Sergius Monastery is located
in the small town of Sergiev Posad, on
the outskirts of Moscow. The Monastery
was founded by the Russian saint Sergius.
Due to the control of the Church and many
wars, Holy Trinity Monastery consists of
a church complex and a military fortress
with a collection of ancient historical
materials and artifacts. The Assumption of
the Blessed Virgin Mary is the largest and
most important of these buildings.

The walls are made of pure white
limestone, and the roof is a blue and gold
star roof in Byzantine style and decorated
with icons inside the building. This
monastery is an outstanding example of
Russian church architecture.

感恩紀念牆
Wall of Gratitude

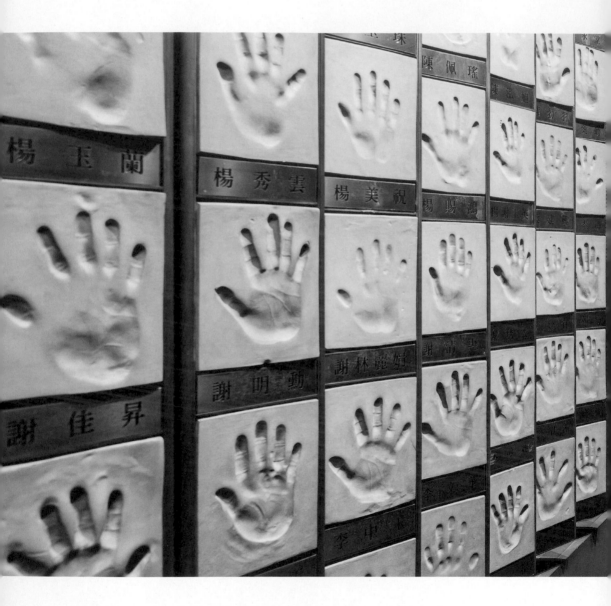

連綿不斷的手印，代表著無限的感恩與傳承
The flows of handprints represent infinite gratitude and legacy.

無數善行的光芒在層層玻璃間璀璨交融，共築此一絢爛莊嚴的壇城
Countless rays of goodness shine and blend within the layers of glass,
constructing this magnificent and solemn altar city.

祝福區
Blessings

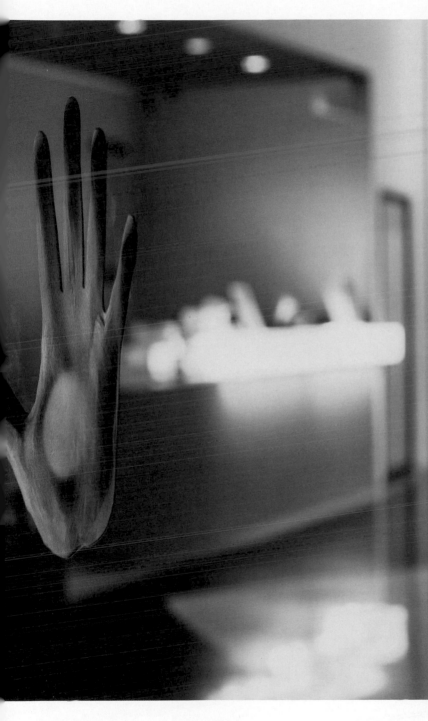

外在的一切
（再有再多
也不會滿足）

找回自己

No amount of material possessions will bring us
happiness.

在參觀尾聲離開博
物館之前，過道左
側牆面設置著祝福
區，印上雙手，螢幕
上顯現雋永的祝福。
呼應著，入館時那句
「百千法門、同歸方
寸」……
提醒您別就此止步，
特展就在往下一層
樓！

Before leaving the
museum, a good wishes
area is set up on the left
side of the wall in the
aisle, put your hands on
the wall and get a timeless
blessing on the screen.
Echoing the phrase
"The doors to goodness,
wisdom and compassion
are opened by keys of the
heart" when entering the
museum...
And don't stop here, there
are the special exhibition
just one floor down!

觀展之道
Visitor's Route

宗教為人們建構出得以安放其中的「根」，又同時給予追尋更高層面事物、具超脫性的「翼」，指向諸多神聖的存在與法則的同時，又關注著個人內心最底層的渴望，宗教此一同時觀照宏觀宇宙和微觀個人的性質，是我們想在常設展中呈現的面向，正如同「百千法門，同歸方寸」此句箴言所示，讓我們在觀覽諸多宗教智慧的同時，結伴踏上追尋自身內心安頓的旅途。

參觀的過程中，您會發現各宗教滿溢光輝的智慧之實如同天上的繁星般數不勝數，但別因此駐足不前，世界宗教博物館在展示中主要依循時間的流逝、行走、特殊的能力、反射的能力、觀、辯證等六大主題來做為我們詮釋與連結世界各宗教的基石。

您在展場中的「行走」不僅是單純的前進，亦象徵著朝聖和尋求真理的過程；隨著觀展的過程，您會發現各區之間的「時間的流逝」並不相同，我們能在十數分鐘內經歷宇宙的創世與毀滅，亦能透過文物感受歷代傳承的悠長回憶；許多宗教的儀式音聲中都帶有安定的功能與特殊的宗教意涵，我們也將這些帶有「特殊的能力」的聲音運用在展場中。

以上種種對於感官的牽引能為您帶來與過往不同的視野，無論是內觀自我亦或是感受宗教的神聖性，此種「觀」的轉變，能消彌人我間的界線，進而在延續整個人生的「辯證」過程中，提供另一種非二元對立的觀點，促成更為包容與友善的交流與對話，最終，「反射的能力」於焉而成，個人的靈性之旅與光輝明亮的群體經驗連結在一起，成就「一即是全，全即是一」的輝映網絡。

Religion constructs the "roots" where people can find a sense of belonging and solace and simultaneously provides the "wings" to pursue higher realms and spiritual transcendence. It points towards the many sacred and transcendent aspects beyond individual existence and the observable laws of nature, while also addressing the deepest desires within each individual's heart. The inclination of religion to look at both the macrocosm of the universe and the microcosm of the individual is what we want to present in the Museum of World Religions, as the motto "The doors to Goodness, Wisdom and Compassion are opened by keys of the heart" suggests, so that while we appreciate the wisdom of many religions, we can accompany each other on a journey to find our own inner peace and pathway to enlightenment.

During your visit, you will discover the abundant wisdom of various religions shining like countless stars in the sky. However, do not linger only on that, as the Museum of World Religions primarily follows six major themes to interpret and connect the foundations of religions worldwide: passing time, walking, enchantment, reflexivity, seeing, and dialogue.

In this exhibition, the theme of "walking" epitomizes not only physical movement but also pilgrimage and the quest for "truth". As you progress through the exhibition, you will notice that "Passing Time" varies in different sections. Within a span of a few minutes, you can experience the creation and destruction of the universe, witness the journey of individual lives through artifacts, and dwell on the flow of time. Reflecting on the past, you will feel a profound sense of connection to the enduring narratives passed down through generations. In many religious rituals, music, chanting, and prayer have a calming and healing effect while carrying profound religious contexts. We have incorporated these sounds and their "enchanting" abilities throughout the exhibition.

All these compelling sensory experiences can offer you a new perspective, allowing you to explore different dimensions, whether it's personal introspection or immersing yourself in the sanctity of religion. This transformation in "seeing" helps deconstruct the boundaries between self and others, fostering a more inclusive and compassionate exchange and dialogue throughout the ongoing process of "dialogue". Ultimately, this leads to "reflexivity," where individual spiritual journeys connect with transcendent collective experiences, forming an illuminating network where "One is All, All are One."

延伸

Extend

從生命之道延伸的各式展覽

Exhibitions based on the path of life.

生死晝夜：於死亡中前行
Bright as night , dark as day : A Walk with the Death

> ❝ 生命是永恆的，愛是不朽的。
> 而死亡，
> 則不過如同黑暗與白晝的一個分界線罷了。❞
> ——肯內斯・克拉瑪《宗教的死亡藝術》

值此戰爭與疫情紛沓而至的時刻，我們同死亡的距離似乎從未如此之近，不幸的是，對於死，恐懼多過於對未知的想像能力。曾經在文明的懵懂時期，自然萬物成為了人對與死亡的認識與想像，之後再由宗教的生死觀，呈現了諸多死後世界的面貌，成為人對生命的完整觀照。

在這個疫情與戰爭改變許多人生命的時刻，我們不妨跟隨前人的腳步行進，透過一場未知的旅程，去想像死後世界的種種可能，如果生命的結束是另一場探索旅程的開始，那麼迎接我們的會是什麼？「生死畫夜」特展正是一趟關於生命的體驗之旅，我們誠摯邀請觀眾一同在知識與體驗的沈浸中想像生與死，這不僅是一趟穿越死亡的旅途，更是在此刻的陰霾中面向新生的契機。

> ❝ Life is eternal, love is immortal,
> and death is only a horizon between dark and light. ❞
> ——Kenneth Kramer, The Sacred Art of Dying

During this period marked by war and disease, we have seemingly never been closer to death. Unfortunately, the fear of death far outweighs imaginations about the unknown. While people's understandings and imaginations of death were shaped by natural phenomena during earlier stages of civilization, concepts for an afterworld were later constructed through religious views on life and death that revealed a more holistic view of life.

As the pandemic and war continues to change lives around the world, why don't we go on a journey into the unknown and explore the afterlife following the footsteps of those before us? What will be waiting for us on the other side if the end of life actually leads to a new beginning? The special exhibition, Bright as Night, Dark as Day, is an experiential journey through life. We cordially invite viewers to imagine life and death through both knowledge- and experience-based perspectives. This will not only serve as a journey through death, but also a new opportunity for rebirth amid the current darkness.

GUIDE BOOK
OF
MUSEUM
OF
WORLD RELIGIONS

宗教文物之美

創辦人｜釋心道
發行人｜釋顯月
主編｜馬幼娟
文字編輯｜林昱宏、苑默文、張庭源、王彥麒
美術編輯｜弓長張

出版｜世界宗教博物館
新北市永和區中山路一段236號7樓
電話｜（02）8231-6118
www.mwr.org.tw

ISBN｜978-626-98786-0-4
二版一刷｜2024年7月
定價｜新台幣700元